PEGASUS
Library

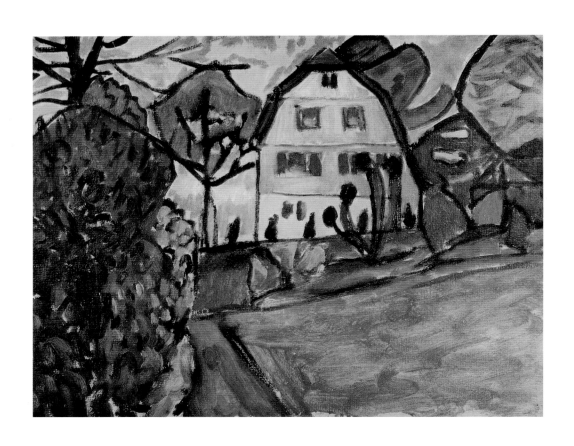

ANNEGRET HOBERG

WASSILY KANDINSKY
AND
GABRIELE MÜNTER

Letters and Reminiscences
1902–1914

PRESTEL

Munich · London · New York

Jacket and spine: Wassily Kandinsky,
Impression III – Concert, 1911 (detail),
Städtische Galerie im Lenbachhaus, Munich
Frontispiece: Gabriele Münter, *Country House
(The Russians' House)*, 1910. Private collection

Translated from the German by Ian Robson

© Prestel Verlag, Munich · London · New York, 2001
(first published in 1994)
© of all works by Wassily Kandinsky and
Gabriele Münter by VG Bild-Kunst, Bonn 2001

Prestel Verlag
Mandlstrasse 26 · 80802 Munich
Tel. (089) 38 17 09-0, Fax (089) 38 17 09-35;
4 Bloomsbury Place · London WC1A 2QA
Tel. (0171) 323 5004, Fax (0171) 636 8004;
16 West 22nd Street · New York, NY 10010
Tel. (212) 627-8199, Fax (212) 627-9866

Prestel books are available worldwide.
Please contact your nearest bookseller
or one of the above Prestel offices for
details concerning your local distributor.

Die Deutsche Bibliothek – CIP-Einheitsaufnahme and
the Library of Congress Cataloging-in-Publication data
is available

Cover design by Matthias Hauer (paperback)
Typeset and printed by Passavia Druckservice GmbH, Passau
Bound by Conzella, Pfarrkirchen

Printed in Germany on acid-free paper

ISBN 3-7913-1374-6 (hardcover)
ISBN 3-7913-2596-5 (paperback)

Preface

6

Art and Love: Kandinsky und Münter
in Murnau and Kochel

9

Prologue: Kochel 1902

31

Murnau and Kochel: 1908-9

45

Murnau, Moscow and Munich: 1910

65

Murnau, Berlin and Bonn: 1911

105

Tension and Separation: 1912-14

129

Epilogue

155

PREFACE

This book presents for the first time in a comprehensive and contextualized selection the main body of the correspondence between Wassily Kandinsky and Gabriele Münter. It thereby documents a dialogue that offers profound and sometimes surprising insights into one of the twentieth century's most famous artistic and emotional partnerships, between two painters who, during the course of their life together — from 1902 to 1914, and more especially from 1908 onward — were deeply involved in the momentous and dramatic events attending the birth of Modernism.

The sheer quantity of letters that have come down to us renders a selective approach inevitable. We have therefore chosen to concentrate on the periods Kandinsky and Münter spent in Kochel and Murnau. The discovery of Murnau in 1908 and their subsequent stays there provided the two partners with a key source of inspiration for their painting and marked the beginning of the most productive phase of their artistic careers. Moreover, the Murnau years, which witnessed many contacts with fellow-artists, are inseparably bound up with the genesis of that revolutionary association of kindred spirits, *Der Blaue Reiter* (The Blue Rider). However, the letters that illustrate Kandinsky's and Münter's life and work in Murnau could not be fully appreciated without a knowledge of the events in Kochel, the scene of their first emotional involvements.

In the arrangement of this unique collection of source material, we have, wherever possible, preserved the coherent sequence of the letters, so that the reader — even without a detailed knowledge of all the circumstances — may follow the lively dialectic of question and answer, action and reaction. Finally, we have taken pains to include key statements by each partner that shed light on his or her individual character and attitude, and

on the factors that determined why the relationship developed as it did.

Over 1200 pages of correspondence have been preserved — Kandinsky's letters often run to six or more large sheets, Münter's to twelve or more smaller pages. In view of the sheer wealth of material there is always the danger that an editor might — consciously or unconsciously — be biased in his or her selection of excerpts, favoring one of the parties over the other, or emphasizing particular traits of personality. However, we would venture to predict that the publication of the complete correspondence, which is currently in preparation, will by and large only corroborate what we learn here about the two artists. In his authoritative work *Kandinsky und Gabriele Münter*, published in 1957, Johannes Eichner — Münter's later companion — surveys the correspondence as a whole, together with Münter's notes written during the First World War when she and Kandinsky were separated, and concludes: "If we could explore the facts in sufficient depth, we would have the material for an enthralling novel." With the aid of the excerpts published here the reader may be able to reconstruct a chapter or two of that novel.

The seeker after intimate confessions and sensational revelations will be disappointed. Yet it is safe to say that few will fail to be moved by these fascinating glimpses into the sublime, the banal, and the ordinary human aspects of the life of a far from ordinary couple in a world still built upon bourgeois conventions, where the attempt to base a partnership upon equal rights of man and woman was no easy undertaking — glimpses that illuminate the workings of two creative minds which shared a common goal, yet were not spared the agonies of self-doubt and inner loneliness.

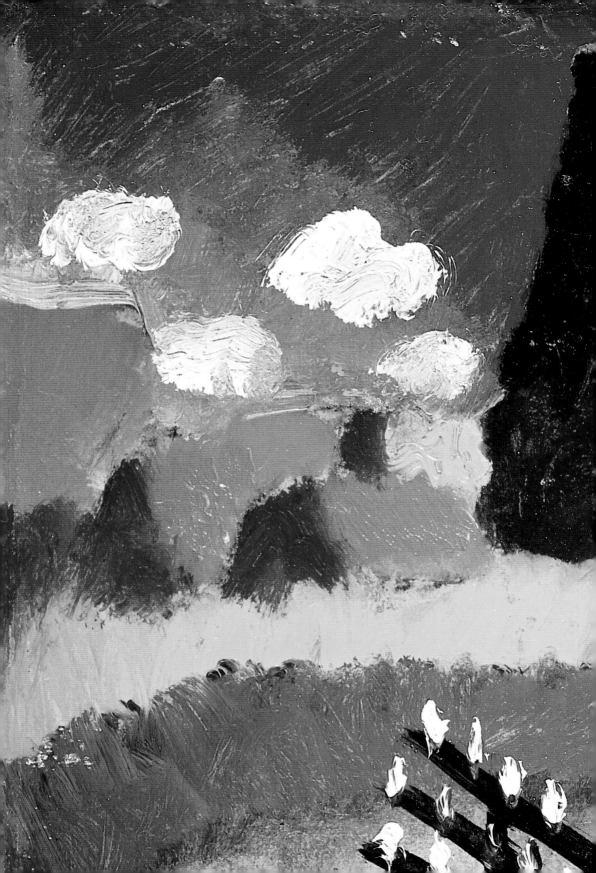

ART AND LOVE:
KANDINSKY AND MÜNTER
IN MURNAU AND KOCHEL

The couple's first encounter took place at the beginning of 1902, when Gabriele Münter — who since May 1901 had been studying under Maximilian Dasio and Angelo Jank at the school of the Künstlerinnen-Verein (Women Artists' Association) in Munich — enrolled in the Phalanx art school, which had recently been founded by Wassily Kandinsky, the sculptor Wilhelm Hüsgen, and other progressive artists. In the summer of 1902 Kandinsky took his class on a painting expedition of several weeks' duration to Kochel, in the foothills of the Bavarian Alps; it was here that a closer acquaintance began to develop between teacher and pupil, as is well documented in Münter's reminiscences. Kandinsky, who at the time was married to a Russian cousin, Anja Chimiakin, must already have realized that his feelings for Münter were more than just casual, for he asked her to leave Kochel at the end of August, when his wife came to join him. Münter acceded to his wishes and spent the rest of the vacation in Bonn, while Kandinsky stayed on in Kochel until the end of September. In October, when both were back in Munich, the relationship soon became more serious, with Kandinsky evidently playing the active role. His letters now alternate between *Sie* (the second-person pronoun of formal address) for "official" communications, and the familiar *Du*. Münter's "diary-letter" of October 12 indicates that the first exchange of kisses occurred at this point. Unfortunately we possess no further letters from Gabriele Münter for the year 1902; but to judge from the 35 letters and cards that Kandinsky wrote to her up to the end of the year, it is obvious that the contact remained close and that she also wrote to him. Kandinsky's letters during this period reveal the exultation of a man in love, but also point to a degree of emotional uncertainty. It appears that Münter — and who can blame her? — repeatedly rejected his advances and questioned the sincerity of his love, as she was not prepared to conduct an undercover affair that might escape the notice of his wife, and required that he make a definite commitment. Only a few weeks old, the relationship between Münter and Kandinsky was already showing all the exhilaration and pain of true love.

◁ Detail from fig. 1

Kandinsky's wooing continued the following year, unabated by lengthy absences of his beloved on vacation in the Rhineland. In the summer of 1903, after some hesitation, Münter again decided to take part in a painting expedition with Kandinsky's Phalanx class, this time to Kallmünz in eastern Bavaria. As she records in one of her reminiscences, Kandinsky had spoken beforehand with his wife Anja, who had agreed in friendship to give up her claim on him. In Kallmünz, as is well known, Kandinsky and Münter celebrated their "engagement," and it was here that the first intimacy took place, as we may glean from an isolated allusion of Münter's in her old age. After this time together Münter spent several months staying with members of her family in Bonn, and did not meet Kandinsky again until November, in Würzburg. Following this, Münter, who since her arrival in Munich in the spring of 1901 had been staying at the Pension Bellevue at No. 30 Theresienstrasse in the Schwabing district, moved into a small studio apartment in Schackstrasse, near the Siegestor. Kandinsky, however, was urging the need for a "trial" period together, as far away as possible from Munich and his marital ties to Anja, to whom he felt far more committed than conventional decency would have required. At the end of March 1904, therefore, Münter traveled to Bonn and waited six dull weeks for her travels with Kandinsky to begin.

The tour of Holland in May and June 1904 marks the beginning of an unsettled period — lasting until 1908 — during which the couple were constantly on the move. After their return, Münter again spent six months in Bonn, while Kandinsky stayed in Munich; in September 1904 he finally left his wife and dissolved the conjugal household at No. 2 Friedrichstrasse in Schwabing. At the beginning of December, Kandinsky and Münter started out for Tunis, where they stayed several months, returning to Munich via Italy in April 1905. From May to August they took rooms in Dresden, and explored the surrounding countryside on foot. In November, the couple went to Brussels on the first stage of a tour that was to take them out of the country for over eighteen months. By way of Milan they reached Rapallo at Christmas 1905, and spent the next few months there, before moving on to France, staying from May 1906 to June 1907 in Sèvres, near Paris. A walking and cycling tour through Switzerland followed in the summer of 1907, and from September of that year to April 1908, Kandinsky and Münter lived in Berlin.

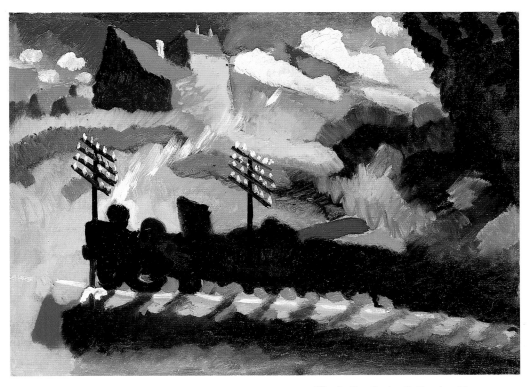

These "vagabond" years of improvised togetherness, far removed from the normal context of everyday life, undoubtedly constituted a less than ideal footing for the decisive early phase of the relationship. It was Kandinsky who had wished it thus, and we cannot therefore absolve him of all blame when we seek to explain why the relationship ultimately could not endure. For we must remember the heavy pressures to which Münter was continually subjected, as an unmarried woman seen to be living in "sin." It was difficult enough for her to justify to her own siblings a relationship that was so much at odds with conventional ideals of domestic happiness; and it is hardly surprising that she herself still cherished some of these ideals, inasmuch as she wished that Kandinsky should acknowledge her officially and without reservation. "I renounced what in my eyes would have been life, home," she commented toward the end of her life, and in one of her notebooks she corrected Johannes Eichner, whom she accused of painting an excessively rosy picture of her time with Kandinsky in Rapallo: "The life was too

provisional to be satisfying — I could not change it, and put up with it for his sake, because he was suffering." On the other hand, Münter's early letters from the years 1903-5 show evidence of attitudes and traits that were scarcely compatible with Kandinsky's idealistic vision of a blissful, perfect union in love and work, and this also may well have helped to undermine the chances of a lasting relationship. However, it is impossible to pass final judgment on this question, especially in view of the fact that none of Münter's letters from the years 1906 and 1907 have been preserved. A further clue is supplied by the reminiscences of the aged Münter, which suggest that the bleak and debilitating mood under which Kandinsky labored, especially during the unhappy year in Sèvres, was partly due to artistic doubts, but mainly induced by pangs of conscience about his wife. "K. felt a deep bond of friendship and respect toward his first wife, Anja Chimiakin, who was his cousin and the companion of his university days." Münter mentions more than once that Kandinsky suffered under his past "and under the sacrifice Anja had made for him." Nowhere, however, does she assert that her unhappy lover was by nature depressively or destructively inclined — a conclusion later drawn by many commentators on the basis of a superficial reading of his self-recriminatory writings relating to this period.

After their return from Berlin in April 1908 Kandinsky and Münter soon set off again for South Tyrol, where they hiked through several valleys and lodged for a time in Lana. Here they produced their last oil studies in the neo-Impressionist style, relying largely on the palette-knife, that had characterized their work over the preceding years. When they returned to Munich on June 8, 1908, they had already decided to settle either there or in some attractive locality in the surroundings. On one of their excursions, between June 17 and 20, they discovered the old market town of Murnau on the Staffelsee, at the foot of the Bavarian Alps. Enchanted by its picturesque situation on a kind of natural terrace, surrounded by a flat plain but set against the impressive backdrop of the Alps, the couple enthused about the town and its environs to their artist-friends, Alexej Jawlensky and Marianne von Werefkin, who in turn traveled to Murnau a short time later, taking rooms at the Gasthof Griesbräu in Obere Hauptstrasse. After one further tour, this time to the lakes of the Upper Austrian Alps from July 27 to August 8, Kandinsky and Münter followed a call from their friends and returned to Murnau.

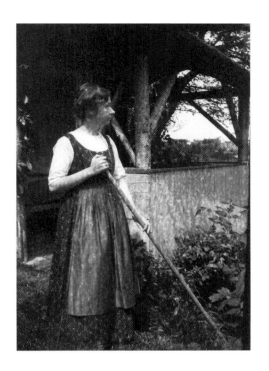

2 Gabriele Münter working in the garden
 in Murnau, 1909

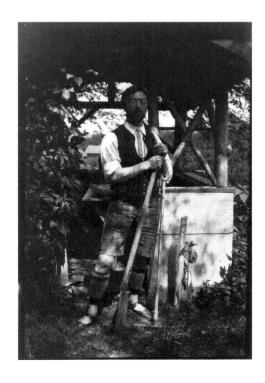

3 Kandinsky working in the garden
 in Murnau, 1909

These weeks in Murnau, from mid-August to September 30, 1908, painting with their friends in the glorious late-summer weather, proved to be a turning point in Kandinsky's and Münter's personal life and artistic development. Here, after years of seeking, both finally discovered their own means of pictorial expression. The intense light of the sub-Alpine region, which often shows very little atmospheric refraction and therefore reveals the colors and contours of landscape and buildings with unusual clarity, helped to take the scales from their eyes and liberate the faculty of seeing. In a remarkably fluid and spontaneous style, they began to paint views of the town in strong colors, and soon afterwards of the surrounding countryside with the Murnau plain and the silhouette of the Alps. Münter displayed particular energy on these group expeditions across country, painting up to five oil studies in a single day. She describes the decisive breakthrough in her painting in succinct, oft-quoted words: "After a short period of agony I took a great leap forward — from copying nature — in a more or less Impressionist style — to feeling the content of things — abstracting — conveying an extract." In her recollections she also stresses the positive and stimulating effects of working with her colleague Alexej Jawlensky. It was from such beginnings that the Blue Rider group later emerged.

Meanwhile, concrete plans were in hand to establish a more settled form of existence after the years of traveling around. On September 4, Kandinsky returned to Munich for a few days to supervise the move into an apartment he had rented at No. 36 Ainmillerstrasse in Schwabing. This was in preparation for the establishment of a joint household, though for the meantime the couple continued to live apart: for the next year, following her return from Murnau in the fall, Münter's principal residence was the Pension Stella, a lodging house in Schwabing's Adalbertstrasse, not far from the studio she had rented on the same street.

In December 1908, Kandinsky spent a few days in Kochel, and in Urfeld on the Walchensee, where he met his Russian friends, the musicians Thomas von Hartmann and his wife Olga, arranging with them that all four should spend a fortnight together in Kochel that winter. During this sojourn, which lasted from February 22 to March 8, 1909, Kandinsky and Münter — besides going on excursions with the Hartmanns — painted a number of winter pictures. January of that year had seen the foundation

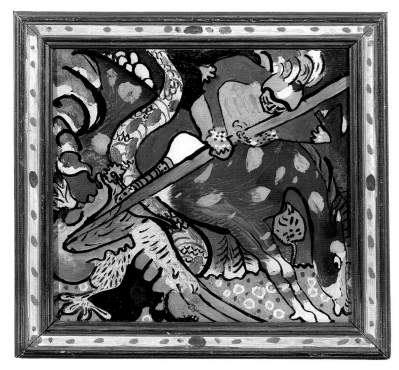

4 Wassily Kandinsky, *St. George I,* 1911, glass painting

of the Neue Künstlervereinigung München (New Artists' Association Munich), a fruit of the couple's contacts with the "Giselists" — Marianne von Werefkin and Alexej Jawlensky — whose salon in Giselastrasse, also in the Schwabing district, was the scene of many a stimulating discussion on art. Other founder members of the association, under Kandinsky's chairmanship, were the painters Adolf Erbslöh and Alexander Kanoldt, and the art-lovers Dr. Oscar Wittenstein and Dr. Heinrich Schnabel. Their ranks were soon swelled by Vladimir Bechtejev, the Burliuk brothers, Erma Bossi, Moissei Kogan, and Alfred Kubin.

The year 1909 saw important developments in Murnau. Kandinsky and Münter returned there in the spring, along with Jawlensky and Werefkin, with whom they initially lodged at the Volks Bazar, a boarding house in Pfarrgasse run by the Echter family. It was to be a highly productive summer, in the course of which Gabriele Münter painted such pictures as *Jawlensky and Werefkin in the Meadow* and *Portrait of Marianne von Werefkin.* In June "we moved to stay with Xaver Streidl — in the newly built villa that Kandinsky had fallen in love with at first sight. To this

love he has remained faithful. There was a lot of debate — he put a certain amount of pressure on me — by the late summer the villa had been bought by Miss G. Münter."

This oft-quoted diary entry of Münter's from 1911 unwittingly helped to cement one of the many later legends regarding her relationship with Kandinsky, namely that the Russian expatriate had lived off her money. The fact of the matter is that during the years they were together — before the First World War — each had a private income, albeit not particularly lavish. Münter, both of whose parents were dead, received her allowance from her brother Carl, in Bonn, who administered the estate; thanks to his imprudent dealings, however, this was considerably reduced from 1913 onward. Kandinsky's income came from the letting of a house he owned in Moscow and irregular transfers of money from his parents; from 1912 onward he was able to supplement this to a more substantial degree by sales of his pictures. In 1913 he sold his property in Moscow to build a larger house, with several apartments, on a newly acquired plot of land; however, this investment brought him little profit — in fact, during the war years in Moscow he had problems getting a roof over his own head, before finally losing what was left of his assets in the Russian Revolution. For Münter, who had also been reduced to straitened circumstances by the war, inflation, and the dwindling of her inheritance, it was fortunate that she still had the house in Murnau to live in when she returned from her Scandinavian exile in 1920. The purchase of the "villa" in Kottmüllerallee on the far side of the Munich–Garmisch railroad was eventually finalized on August 21, 1909. During their years together in Murnau, Münter and Kandinsky did a great deal of work on the house and garden, painting the furniture with motifs inspired by naive art, and adorning the walls and tables with folk art of a religious nature and examples of local handicraft, in which they both took a particularly strong interest.

This leads us to consideration of another factor that significantly influenced the direction of the couple's work during this fruitful phase in Murnau — the discovery of Bavarian and Bohemian glass painting and the technique known as *Hinterglasmalerei*. In Münter's recollection it was Jawlensky who first drew the friends' attention to the substantial collection of glass paintings owned by a local brewer, Johann Kroetz (these works are now in the town museum at Oberammergau). Münter at once began to

5 Gabriele Münter, *Bavarian Landscape with Farmhouse*, ca. 1911,
 glass painting

copy old examples of this genre and to learn the technique from
Heinrich Rambold, a glass-painter still active in Murnau at the
time. She soon infected Kandinsky and other artist-friends with
her enthusiasm, and by 1911 Franz Marc, August Macke, and
Heinrich Campendonk were also trying their hand with the
technique. With its patchwork of brilliant, unmixed colors, its
simple black contours, and the naive directness of the senti-
ments it expressed, glass painting — along with other elements
of folk art — became a vital source of inspiration for the work
of the emerging Blue Rider group.

Kandinsky and Münter stayed in their new house in Murnau
until September 20. In Münter's sketchbooks we find, alongside
her drawings, numerous notes of things acquired for the house
and garden. Nor should we overlook the large number of excel-
lent, graphically clear black-and-white photographs dating from
that summer and later, most of which were taken by Gabriele
Münter to document her new surroundings. The couple visited
Murnau again in October. Then, in December, came the first
exhibition of the Neue Künstlervereinigung München, staged at
the Thannhauser gallery, which was subsequently shown in sev-
eral other German cities, thereby giving the NKVM artists a first
opportunity to present their work to a wider public, extending
beyond the bounds of the city and the region.

In February 1910 Kandinsky spent a few days alone in Murnau. In April, and during the summer, he and Münter labored intensively in the house and garden, and produced a substantial number of pictures and sketches. In September the second exhibition of the NKVM was held in Munich, this time with international participation, French artists being particularly well represented. At the beginning of October Kandinsky set off on a two-month trip to Russia, staying over in Berlin to visit Münter's sister Emmy and her husband Georg Schroeter. After spending six weeks in Moscow, his native city, he traveled on at the end of November to visit his family in Odessa, arriving back in Munich shortly before Christmas.

By virtue of their quantity and the fact that they have been preserved almost in full, the letters that the lovers wrote to each other nearly every day during this period of separation constitute a central corpus of the correspondence from the Murnau years. It is somewhat surprising to find here a mirror — indeed, virtually a textbook example — of the traditional male-female dualism. In a flush of almost giddy enthusiasm, Kandinsky reports on his impressions and exploits in Moscow — innumerable encounters with friends, relatives, artists, intellectuals, collectors; manuscripts he is writing; lecture and discussion evenings; visits to exhibitions and theaters. Münter, on the other hand, who at the beginning of the exchange of correspondence was spending ten days in Murnau with her friend Hedwig Fröhner, appears in many passages of her letters as a predominantly passive, lackluster individual, given to frequent mood swings of a mainly negative kind, as a captive of her domestic environment, who was later dogged by poor health as a result of dental problems. No wonder, one might think: Kandinsky had after all gone off alone, leaving his companion behind. Originally, however, it had been planned — or perhaps only vaguely suggested — that Münter should join Kandinsky in Russia toward the end of his stay and the two should travel home together. Münter did in fact start looking around for a suitable outfit for the journey, but soon abandoned the idea as involving too much trouble and expense. It might also be pointed out that Münter's epistolary style, which records the slightest variations of mood and other trivial observations, was dictated by the mutual promise to give each other daily a detailed "report," as she often calls it. Kandinsky's letters are also full of detail, and written just as frequently, yet they are infused with a different spirit. It should also of

course be borne in mind that the scope of activity for Münter — in Ainmillerstrasse she only had the housekeeper Anna Gruber for company — was more limited than for Kandinsky, whose contacts with family and old friends provided him with a wealth of social opportunities in more elevated circles. Münter did have the opportunities for outside contacts enjoyed by other women artists such as Marianne von Werefkin, Elisabeth Epstein, and Hedwig Fröhner; usually, however, she preferred to keep to herself, a decision reinforced by real or imaginary perceptions of coolness in friends such as Werefkin and Jawlensky. Observations of this kind — for reasons of space, only a few are included here — frequently elicit words of sympathy and encouragement from Kandinsky, but also exhortations to be more conciliatory. One reads the letters, which are so different in tone, with a certain sense of unease. It is especially surprising to find Münter complaining so often of listlessness and lack of motivation, for in reality she was extremely productive during this period. In the fall of 1910 she painted a large number of pictures; occasionally, she describes how some of these works took shape, and Kandinsky regularly praises her and urges her to continue with her efforts. It is evident that Münter painted very quickly, often completing one or more large-format pictures in a single afternoon. The fact that she carried on working, despite her doubts about her own abilities, is one of the most notable characteristics of Münter the artist. At no point in her life — not even in the 1920s, when she was financially and artistically at a very low ebb — did she contemplate giving up painting in favor of some other career.

On the evening of January 1, 1911, Kandinsky and Münter met Franz Marc for the first time at the Giselastrasse apartment of Jawlensky and Werefkin. After the critics had lambasted the second NKVM exhibition the previous fall, Marc had published a favorable review of his own; this brought him into contact with Adolf Erbslöh and later with other members of the association, which he himself joined in January 1911. He and Kandinsky became close friends, and were soon the leading lights of the group; during the summer they worked together on a project for an art almanac, to which they gave the name *Der Blaue Reiter.* In May, Kandinsky went to Murnau on his own for a few days, one of his aims being to confer with his new friend Franz Marc in Sindelsdorf. During his absence from Ainmillerstrasse, Münter wrote the retrospective diary that is published here as a

chronicle of the years 1908-9. At the end of June, Münter set off on a two-month journey to visit relatives in Berlin, Herford, and Bonn. One of the purposes of this temporary separation was to give the partners a chance to recover from the exertions of recent months — and to give them a rest from each other, as allusions in Münter's diary and in the first few letters would seem to indicate.

Kandinsky spent the unusually hot summer of 1911 almost entirely in Murnau, devoting himself enthusiastically to the care of the garden and to the preparation of several new series of pictures. Now and again he cycled over to Sindelsdorf to see Franz and Maria Marc, who in turn paid their first visit to Murnau in July. Münter spent the first four weeks of her travels in Berlin, staying with her sister Emmy and family, visiting various museums, and also contacting the collector Bernhard Koehler — an uncle of August Macke, and a patron of Marc — who was soon to become the Blue Rider's most important supporter. Münter subsequently went to Herford, in Westphalia, where she also stayed with relatives. In many of his letters, Kandinsky, seconded by Franz Marc — both artists were very keen to get publicity for the NKVM — urges her to visit the directors of the new museums in the Rhein/Ruhr district, telling her to introduce herself, and the aims of the association, to such figures as Karl Ernst Osthaus in Hagen, Ernst Gosebruch at the Folkwang Museum in Essen, Richard Reiche of the Barmen Kunstverein, and Alfred Flechtheim, the Düsseldorf gallery-owner. Alfred Hagelstange, director of a museum in Cologne, is seen as a particularly good prospect. During a recent visit to Munich, Hagelstange had been invited by Kandinsky and Marc to the studio in Ainmillerstrasse for a viewing. He had been particularly impressed by Münter's paintings and had hinted at the possibility of a solo exhibition — so now the two friends, almost boyish in their exuberance, press Münter to beard the lion in his Cologne den. Münter was initially skeptical about doing the rounds of the museums, having little confidence in her canvassing talents. She stayed on in Herford longer than planned, and on her way to Bonn at the beginning of August did not bother to stop over in Hagen and the Ruhr district. Subsequently, she overcame her reservations and set out from Bonn on a brief tour that took her to Hagen, Essen, Düsseldorf, and Cologne — however, Hagelstange was away when she called. While Münter does not seem too perturbed at missing this opportunity, Kandinsky

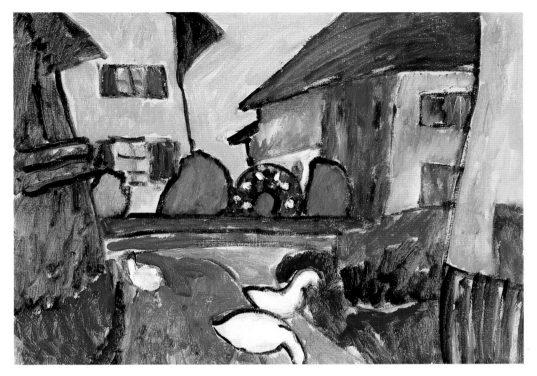

6 Gabriele Münter, *Geese in Seehausen*, 1910

makes no attempt to conceal his disappointment; and Münter never did get to have her show in Cologne. But while staying in Bonn with her brother, who was interested in contemporary art and had acquired a small collection of pictures, she met August Macke; the two took an initial liking to each other, and spent a considerable amount of time exchanging views on artistic matters.

The correspondence from 1911 is replete with fascinating details, but it is also noticeable that Kandinsky's letters, though still warm and friendly, are no longer infused with the exuberance of young love, and fail to show the same degree of affection as those of the previous year. Although Münter now appears more emotionally stable than in 1910, she has clearly noticed the change in tone. She tells him that she is missing him, and wonders cautiously whether her feelings are reciprocated, but Kandinsky refuses to take the hint. His letters also make frequent reference to Fanny, the housekeeper who had replaced Anna Gruber at the beginning of 1911. Fanny Dengler had worked for Kandinsky and his wife Anja years before, and she was not

kindly disposed toward Münter, whom she regarded as responsible for the breakup of the marriage (which at the beginning of 1911 was not yet officially dissolved). In later years Münter came to regard Fanny's presence as more than just an ancillary factor in her estrangement from Kandinsky, although she never accused him of having felt anything more than friendship and "exaggerated pity" for the housekeeper.

Münter returned from her travels at the end of August 1911. In October, the house in Murnau became the venue for the legendary week-long editorial conference — attended by Franz and Maria Marc, August and Elisabeth Macke, Helmuth Macke, and Heinrich Campendonk — that gave birth to the *Blue Rider* almanac. These "unforgettable days," during which papers were read and heatedly discussed, and the almanac gradually took shape, are graphically described by Elisabeth Macke-Erdmann in her memoirs. Toward the end of the year, a schism occurred between the moderates and the progressives in the NKVM: when the jury for the third exhibition rejected Kandinsky's *Composition V*, the artist resigned from the association, together with Franz Marc, Gabriele Münter, and Alfred Kubin, and hastily organized a counter-exhibition. This "First Exhibition of the Editorial Board of The Blue Rider" took place at the Thannhauser gallery in Munich from December 18, 1911, to January 1, 1912; besides the work of the *Blue Rider* editors, it included pictures by Robert Delaunay, Elisabeth Epstein, Eugen von Kahler, Henri Rousseau, Albert Bloch, and Arnold Schönberg. The show subsequently went on tour until 1914, visiting a number of cities and bringing the Blue Rider firmly into the public eye.

The couple went to Murnau again in June 1912 and spent most of the summer there. From October until shortly before Christmas, Kandinsky was again in Russia, traveling via Berlin to Odessa, and thence to Moscow. Once more, the tone and content of the correspondence changes. This is partly due to the events surrounding the Blue Rider exhibition: as a result of the many new contacts with galleries, collectors, publishers, and critics, the couple's everyday life had become considerably more hectic. Münter has a lot to say in her letters about problems with the dealer Hans Goltz; she also reports at length on the outrageous behavior of a prospective buyer, and informs Kandinsky of disparaging comments by Franz Marc and his wife. Whenever the press or other artists are critical, she is sure to let Kandinsky know. To the urbane, sophisticated intellectual —

7　Wassily Kandinsky, *Study for Autumn Landscape I,* 1910

which is how his contemporaries always characterize Kandinsky — these petty enmities and squabbles must have been highly irksome. However, he tries hard to conceal his annoyance, and even acquiesces to her when she advises him to drop his plans for a one-man show at the Goltz gallery because of the trouble with the dealer.

To understand why Münter allowed herself to become so upset about such things, one has to remember that in the spring of that year she had fallen out with Marc and Macke. This quarrel within the Blue Rider circle, coming as it did at the height of the group's success during the second exhibition at the Goltz gallery, is fully documented — not always in the most genteel terms — in the correspondence between Macke and Marc, and between their respective wives, which was published some years ago. The letters between Münter and Kandinsky show that, on this occasion, Münter's companion had taken her side. In the meantime, Münter's relationship to Franz and Maria Marc had been patched up to some extent, but there had been no recon-

ciliation with Macke, who was now also becoming disenchanted with Kandinsky's art. All this unpleasantness no doubt contributed to the marked decline in Münter's artistic output, compared with previous years. For Kandinsky, however, the years 1911 to 1913 were exceptionally productive: experimenting with his *Improvisations* and *Compositions*, he moved forward to full-blooded abstraction. It might be thought that, as the dominant creative personality of these years, he effectively cramped his partner's style. But that can hardly have been the case: all the evidence indicates that, whatever the state of their personal relationship, Kandinsky and Münter had a deep mutual understanding on the artistic plane, and each had a high opinion of the other's talents. They were always of one mind as to whether a work of art was genuine and *innerlich*, infused with inward life, or still at the *äusserlich* stage, externally determined, superficial. And in later years, Münter would stress that Kandinsky had always acknowledged, protected, and nurtured her talent. Indeed, Kandinsky scarcely misses an opportunity to urge her to work, to encourage her in her positive moods, and congratulate her on her successes. One might even go so far as to say that the desire for an artistic partnership and the stimulus it provided was one of the main reasons why Kandinsky fell in love with Gabriele Münter. There is plenty of evidence to show that, when it came to discussing artistic matters, he regarded women of the caliber of Werefkin, Epstein, Olga von Hartmann, or Helene Blavatsky as his equals.

Münter's morale as an artist received a boost at the end of 1912, when the Berlin publisher and dealer Herwarth Walden visited her in her studio at Kandinsky's instigation. He arranged a large exhibition of her work early the following year.

Kandinsky and Münter were in Murnau in March and May 1913, and in June they were visited there by Kandinsky's ex-wife, Anja (the divorce had gone through in 1911). During Kandinsky's absences Anja was always an important contact for Münter, and she is accordingly mentioned quite frequently in the letters. From July to September, Kandinsky was again away in Moscow, this time with the main object of arranging the sale of his house and the building of a new one. The correspondence gives the lie to a further persistent legend surrounding the couple, namely that Kandinsky's decision in 1917 to pass her over in favor of a younger woman came as a bolt from the blue for Münter; we see that, in fact, the tension between the two, latent

8 Gabriele Münter in her and Kandinsky's Munich home, 1913

9 Kandinsky in the couple's Munich home, 1913

since at least 1912, is becoming ever more manifest. In 1912 Münter had already written, "I feel lonely without you & am uneasy about you — & know that with you I feel just as lonely"; and in 1913 she confesses that "for years now" she has not been happy. Toward the end of her life she recalled that once, in 1913, she came very near to packing her bags, and on another occasion she ran out of the house and wandered around in the English Garden for several hours. Matters were not improved by the headaches from which she frequently suffered in 1913 and 1914. But Kandinsky, too, was unhappy: his letters from 1913 reveal signs of weariness, and this "gentle, well-bred nature" (Johannes Eichner) can at times become quite irritable. Münter later wrote that Kandinsky had become increasingly withdrawn and inaccessible: she found it ever harder to understand him, yet he still swore that he could never leave her. Deliberately oversimplifying the complexities of the situation, it would seem that Kandinsky secretly realized he was no longer able to love Münter, but the voice of a guilty conscience and feelings of pity prevented him from fully acknowledging the fact. In her old age Münter described these contradictory feelings as "hardness and coldness" on the one hand, while on the other, "the capacity for love and pity was exaggerated out of all proportion." And she herself was always too "ingenuous and trusting": she lacked the necessary detachment to make a realistic assessment of her situation and its implications for the future.

In April 1914 Kandinsky took his mother to Merano for a vacation. From May onward, he and Münter were again in Murnau for the summer, busying themselves with house and garden. On July 3, the two of them went on an excursion to the Höllental gorge, near Garmisch. Kandinsky distilled impressions of this into his *Improvisation Gorge*: in the preparatory drawing, an apocalyptic horseman is to be seen on the left, echoing the fantasies of doom and destruction found in many of Kandinsky's pictures from this period. At the outbreak of war, on August 1, 1914, Münter and Kandinsky returned to Munich in the utmost haste. On August 3 they left the country, crossing to Rorschach on the Swiss shore of Lake Constance. The parting of the ways came at the end of November, in Zurich: Kandinsky, who as a "hostile alien" was unable to return to Germany, went back to Moscow.

This geographical separation, which was later to become final, brings us to the end of our account. Kandinsky had suggested to his companion that they should no longer live together, but

should continue to see each other as friends. After a wearisome six-week journey he writes from Moscow on December 25, 1914: "I did of course read the letter you gave me on my departure. I would like to help you and bring you joy. I often think how lonely you are now, and it makes me very sad. But I do believe that the way I suggested is the best one. Lately I have acquired a lot of new grey hairs, and the journey was not to blame. My conscience is troubling me. Also the knowledge that many of the things that I ought to do are beyond my power: I cannot help my basic nature. But time will show the way. The long time we are apart — though we did not plan it this way — will no doubt make some things clearer."

Kandinsky's hopes that without him Münter would find her way back to a stable, purposeful life were not fulfilled. On January 1, 1915, he writes: "How dearly I should like to help you. Still I believe — that is, I am sure — that the way I suggested is the best one. You will not be alone, and a constant spiritual warmth will always guard you against loneliness. Each of us will

10 Kandinsky, his former wife Anja, and his mother, 1913

have his full freedom. Without which, as I see ever more clearly, I am not worth much. I am really convinced that you yourself will be very content, will get much more done — bitterness will gradually pass away, and happiness will come to fill the empty space."

In the winter of 1915-16 the couple met in Stockholm for the last time. Münter had gone there to wait for Kandinsky in a neutral country, and had written him many agonized letters. Kandinsky did not have the courage to make the final break there and then. In response to Münter's pleas he even promised to come back again, which was undeniably a grave error on his part.

Most of Münter's jottings from the years 1956-57 reveal that she still felt extremely bitter about the manner of the separation and her subsequent years of loneliness. In one recollection she lists what she sees as the positive qualities of each partner: "In his case there is nobility, goodness, pureness, the capacity to love, genius. In mine, naivety, a childlike nature, faithfulness, undemandingness." And in a note for Johannes Eichner's planned dual biography (1957) she sketches the following picture: "He [Kandinsky] was an idealist and *did not want* to be dishonorable, but when he realized that we really were not made for one another he turned nasty and unjust — he had no bearing — no sense of humor....These thoughts are also important for the book. He failed — and I failed — that's why there was no happy ending."

Let us return, however, to those fateful years of togetherness, brought to life in letters that constitute one of the early twentieth century's most eloquent documents of artistic, historical and human events, illuminating the circumstances under which art, life and love interfused to produce one of painting's finest hours. As far as the development of Modernism is concerned, the period during which Wassily Kandinsky and Gabriele Münter lived and worked together holds a truly pivotal significance. Many historians of modern art have emphasized the key role played by the Blue Rider circle in paving the way toward abstraction and setting the agenda for the emergence of an entirely new concept of painting, redefining the overall function of art in a world whose fundamental structures of feeling had long ceased to accord with traditional ways of seeing and the artistic conventions with which they are intrinsically correlated. Here, the general tendency is to focus on Kandinsky, the tireless

generator and disseminator of ideas, as the prime motive force behind this radically innovative shift in cultural sensibility and artistic practice. Indeed, there can be no denying that it was his theoretical program, articulated in such writings as *On the Spiritual in Art,* and in his early abstract pictures, which provided the vital spark for the Modernist revolution. However, as many of these letters show, Kandinsky was by no means an isolated genius, hatching new ideas entirely on his own, unaided by others. On the contrary, his collaboration with Münter — and with other contemporaries — was an essential factor in the evolution of his thinking. Gabriele Münter, in turn, was an artistic personality in her own right, with clear and definite contours; as a painter, she was fully capable of standing her ground in the face of his more widely recognized brilliance, and in a certain way, she complemented his talents by constituting an antipode to his character and the cast of his intellect. By situating Kandinsky's work in the context of everyday events that helped to shape it, the correspondence with Münter opens up an intriguingly different perspective on Kandinsky himself, and on the process by which the Blue Rider, with all its far-reaching consequences, came into being.

*In her old age, in 1956-57, Gabriele Münter jotted down various
reminiscences for her second partner, Johannes Eichner: among them
we find two accounts of the beginning of her friendship with Wassily
Kandinsky, when she joined his painting class at the Phalanx school
and spent her first summer in Kochel, in 1902. The slightly abridged
text of these reminiscences is published here for the first time in their
proper context.*

Then a student at the Bellevue guesthouse at No. 30 There-
sienstr. invited me along to the interesting Phalanx exhib. in
Finkenstr. There was a collection by the Finn Axel Galén — I
recall Kandinsky['s] bright sunny picture "The Old Town" & 2
sculptors Hecker and Hüsgen. I very much liked Hüsgen's *Masks*
of the 11 Executioners. My fingers began to tingle — a sculptor
I would be. I soon went along to the Phalanx school and en-
rolled in Hüsgen's afternoon sculpture class. This also *involved*
the evening nude with K.[andinsky] — I dropped the evening
nude I had been attending before, and made the most of the
opportunity. And that was a new artistic experience, how K.,
quite unlike the other teachers — painstakingly, comprehen-
sively explained things and regarded me as a consciously striving
person, capable of setting herself tasks and goals. This was some-
thing new for me, it impressed me. — It was also very pleasant
on the IIIrd floor of the Phalanx school on Hohenzollernstr.
When there was not much doing in the Hüsgen class because of
no heating, no model, or the teacher Hüsgen being away, they
told us the sculptors could sit in on the painting class. This was
how I came to do the first still life in oils that K. set as an assign-
ment. And it was at once noticed by K., judged to be fresh and
colorful. Between afternoon and evening nude there was a
break 4-5, and then Olga Meerson, the student representative,
organized tea together at one table. Maria Giesler and Emmi
Dresler were there too. Carl Palme, & the Executioner came to
visit Giesler....Dr. Robert Kothe (lawyer) — the lute player and
singer who gave Giesler singing lessons....For the summer K.
wanted to go to Kochel & Meerson tried to recruit people. I

invited a colleague from the K. [Künstlerinnenverein — Women Artists' Club] to take a trip to Kochel to have a look. I took a room high up on the IInd floor of a house (Puntel, building contractor) that looked onto the plain and to the north....K. told me later that he was very pleased when Miss Meerson told him I had enrolled in his summer school. Then the K. school gathered in Kochel there was Giesler & Dresler, Meerson, the Russian girl Stanukovich, Hedwig Fröhner (her younger sisters Helene & Mariele were visiting her — we had a very jolly evening together, Fröhner had invited just me) — Helene was really good fun — we laughed & sang together, the Fröhner girls knew a lot of folk songs — Swabian....In Kochel K. gave each student a whistle, so he could find us more easily for correcting....We usually had lunch at Ka's hotel ... on the edge of the lake with K., Palme, Meerson etc. Once I was painting on the shore & K. came to correct & found bad colors in it, e.g. emerald green & others. He flung them all onto the grass, they were forbidden. From then on I only used good colors that he allowed. on walk he spoke of colors & blends. At first it was rainy & dull. I had a long rubber raincoat with cape & a splendid bicycle. Thus it was that K. & I cycled around the lake & went on little excursions. The other pupils didn't have bikes. So far I hadn't done much painting. K. was staying at the "Kurhotel" by the lake. all the students had private lodgings....Then his wife was due to arrive — he looked for somewhere to stay & found rooms on the Ist floor at Puntel's house, below me. His wife moved in (with Fanny & housekeeper for him). He invited me to pay her a visit. Afterwards he said they had liked me & the ladies had spoken especially of my beautiful hands, which he himself had not noticed at all before. The next time he was correcting he told me it was embarrassing for him that we were still going on excursions & his wife could not join us as she couldn't ride a bicycle and was not a good walker. It would really be better for me to go home. I was just getting into the swing of painting, since the weather had gotten better — but of course I packed my things and went to Bonn to visit my family. We went on a long cycling tour in the Idar-Oberstein area, where they cut the semiprecious stones. I probably sent K. postcards & got one from him....

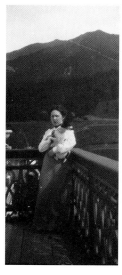

11 Kandinsky's first
wife, Anja, on
the balcony of the
Hotel Grauer
Bär in Kochel,
1902

In the fall school with K. began again, at Hohenzollernstrasse. Morning, afternoon, evening. He got little letters from me, slipped into his coat pocket, & sometimes visited me for "private

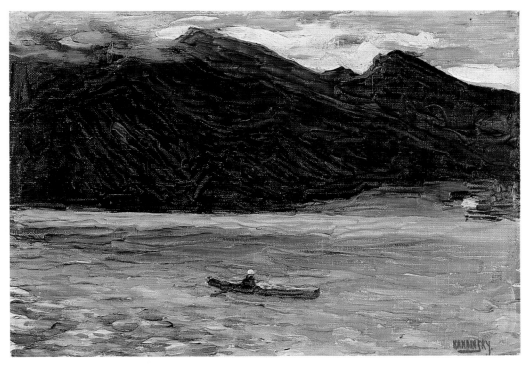

12 Wassily Kandinsky, *Kochelsee with Boat,* 1902

corrections" at the "Bellevue" guesthouse....He was always the gentleman, the reticent suitor, and told me a lot about himself.

In the second account of the early days at the Phalanx school Münter includes another episode that was no doubt of deep significance in the development of the amorous relationship between her and Kandinsky. Robert Kothe, the abovementioned member of the cabaret group known as the Elf Scharfrichter *(Eleven Executioners), who together with his wife had given singing lessons to Gabriele Münter as well as Maria Giesler, plays a central part in the story.*

He [Kandinsky] enjoyed cycling around with me. We sometimes tried to grab one another's handlebars & fell off — and got up again. No harm done. One day the whole group of us went on a trip to the Walchensee. Out in the countryside I lost some of my inhibitions, on the way back I was dancing and singing along the road & noticed that this made an impression on K. & again became decorous and quiet....One day Rob. Kothe visited me from Mnch. [Munich] & K., whom I had invited to tea, was in

my room at the time. Kothe suggested I should go with him to the Herzogstand — I asked K. if he would come with us — K. decided to come along, as he didn't trust Kothe. & all three of us went on the trip & Kothe was somewhat piqued. I didn't understand what was going on, or why it should matter who went with whom. On the way back Kothe soon went on ahead by himself. We had spent the night on the mountain — the men in the general dormitory, I in the bedroom or the small dormitory. I don't remember. At any rate we walked up to the summit. K. was irked & said there was nothing for him to paint. On the way down I leant on K.'s shoulder & soon Kothe had to go to Munich & K. had protected me without me knowing about it. I was too naive.

Among these fascinating reminiscences there is a scrap of paper in Münter's handwriting with the well-known (it was published by Johannes Eichner) and oft-quoted assessment by Kandinsky of his pupil's talent:

Insert as quotation [Münter includes instructions of this kind for Eichner's book on several occasions]: K. the great art teacher despaired of his mission in the case of G. M. — he said, "You are hopeless as a pupil. All I can do for you is guard your talent and nurture it like a good gardener, to let nothing false

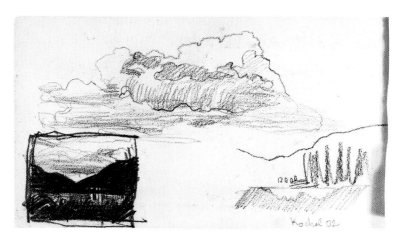

13 Gabriele Münter, *Kochelsee – Landscape*, 1902, pencil drawing
 from the artist's sketchbook

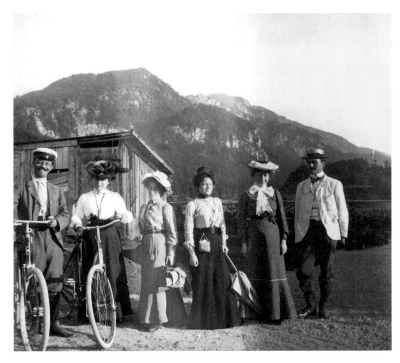

14 Kandinsky with his pupils. Kochel, 1902

creep in — you can only do what has grown within you (your-
self)."

*Later, as she records here, Münter left Kochel at Kandinsky's request
and spent the rest of the vacation staying with her brother and sister
in Bonn.*

*This note, sent to Münter in Bonn, is a reply to a letter that has
unfortunately not been preserved.*

Dear Miss Münter,
Thank you very much for your nice letter, which really gave me
great pleasure....It is a source of the greatest delight to me
that you have so much success and enjoyment with the spatula.
I had of course always believed that lazy M. would one day do
something good. She only needs to have a tiny bit of pa-
tience....

 I have done four studies since your departure. The big roll of
canvas is still standing unopened in the corner....

KOCHEL,
SEPTEMBER 9, 1902
WASSILY KANDINSKY
TO GABRIELE MÜNTER

Yes! I already hear the earnest and richly colored fall coming. Gold-embraided he comes and says, "You! where is your return ticket?" Oh, heavens! The pink flowers have wilted. Where has the summer gone? But I also expect many fine things from the gold-embraided gentleman. Will he bring them?

My wife sends her kind regards

Yours very sincerely

Your comrade W. Kandinsky

In this letter Münter also tells her teacher about the one-week cycling tour she went on with her family to Idar-Oberstein.

COLOGNE,
SEPTEMBER 22, 1902
GABRIELE MÜNTER TO
WASSILY KANDINSKY

Dear Doctor,

I have just received your postcard from Kochel, which followed in my wake via Bonn and Düsseldorf. Thank you very much.... Am at the moment staying with my girlfriend after having 3 days in Düsseldorf for the exhibition, which is really very much worth seeing.... Tomorrow I am going to meet the Misses Giesler & Dresler in Düsseldorf for a merry afternoon — then I'll be here perhaps another day or so, and then back to Bonn, where alas I have not much time left, as at the beginning of October I am planning to travel back to Munich....

Have all your travel plans fallen irretrievably into the Kochelsee then? Was the weather there also so bad all the time until a few days ago? Are the apples already fat and red? and have the trees donned their coat of many colors? I haven't gotten down to work at all again since the modest beginning I made in Bonn and have often railed at the weather. When I think that it is only another 14 days or so until I put my nose to the grindstone again in Munich the vacation by the Rhine seems really to have flown by....

But now I must finally spare you further chatter and close with very kind regards

Your Ella Münter

Münter apparently did not mail the following letter, which is without an envelope; it begins as a letter and ends in diary form. Bearing the same date, there is also an envelope with a diary entry in pencil, which evidences Münter's confusion, and regret, about what had taken place between them — the first exchange of kisses.

Dear K! (That is how you sign yourself & what else am I then to call you) To pass the time, and because I am thinking of you, I will give you a preliminary report and tell you what I have been doing since yesterday evening and some of the things I have been thinking....

Now let me try to tell you something of my thoughts. I believe that with me it is as I already told you at Kochel & Seeshaupt — namely, that — oh my! — (how hard it is for me to say it!) since I came to know you as a teacher I have found you ever more capital and commendable. Then you interested me personally too & I loved you the way — & still do — & always will do — the way most people surely do who have come to know you as I have — & what happened then you are responsible and my none-too-strong character and perhaps also my surprise & the unexpectedness — I couldn't help myself & even now I cannot really. [four lines deleted]

My idea of happiness is a domesticity as cozy and harmonious as I could make it & someone who wholly & always belongs to me — but — it does not have to be that way at all — if it does

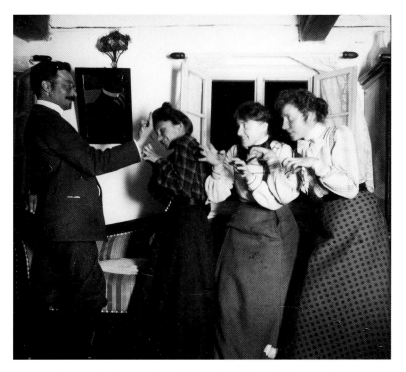

15 Kandinsky, with "the Russian girl Stanukovich," and Helene and
 Hedwig Fröhner, in a hotel room in Kochel, 1902

37

not come about & if I do not find the right man — I am still very content & happy I intend now to find pleasure in work again — & if you are prepared to continue to help me in this I should be very glad — then we shall resume the teacher-friendship-camaraderie relationship & read between the lines that we are & will continue to be fond of each other — this is what I wanted to convey to you back at Seeshaupt — but I don't know if I made it clear enough. At any rate I have always so despised & hated any kind of lying & secrecy that I just could not lend myself to it. If we cannot be friends in the eyes of the world I must do without entirely — I want no more than I can be open about & I want to be responsible for what I do — otherwise I am unhappy....

What will you say — when you read this? Will you agree with everything — will that be it? I cannot tell you this in writing — perhaps I will let you read it one day — I will write to you as in a diary when there is something on my mind — to help myself — you old egotist! (me) Monday, 5 o'clock. Good heavens! Just be sensible and don't get sentimental again. Indeed I have a basic leaning toward sentimentality but I am so dreadfully ashamed of it & hate it really.

I often feel very lonely because there is really nobody to whom I mean anything & of whom I am really fond — apart from my little brother....Well — if I often feel lonely — am a trifle sentimental & besides ... Kandinsky is an awfully dear, nice fellow — I hope I am not so demented as to imagine that to be love....If only I knew what to do! — if I could only find some relief! Damn. The devil take it. I so long for a letter — but the fellow just does not write — what he wants, he needs a greater — stronger — woman — I could not be that, even if I wanted to. Not enough character is my problem & already too warped & spoiled. Either all or nothing — nothing is far far better than half measures — that I cannot accept — Kandinsky let me have peace of mind again!

(An hour later)....You cannot blame me if I at first had my doubts about the depth and duration of your feelings. And such doubts I only had at the very beginning. — What a chump I am — how I hunger for a letter from him — damn. The devil take it once again!

[Note written down the edge of the first page]
I really am a goose — I went walking with him in Kochel arm in

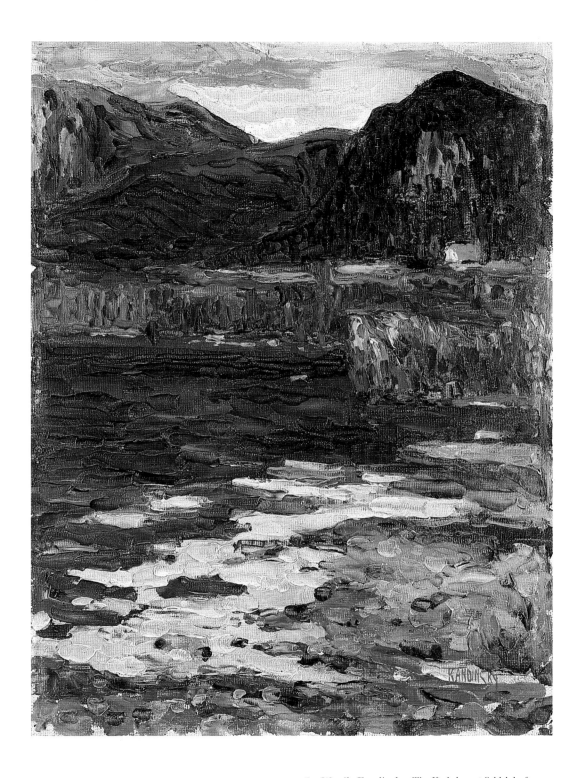

16 Wassily Kandinsky, *The Kochelsee at Schlehdorf*, 1902

arm & had no idea what was to come — but who could have imagined?!

From now on Kandinsky addresses his letters to the Pension Bellevue on Theresienstrasse in Munich's Schwabing district, where Münter had taken a room again after returning from her vacation.

MUNICH,
OCTOBER 14, 1902
WASSILY KANDINSKY
TO GABRIELE MÜNTER

Dear Miss Münter,

I shall be glad to come on Thursday at 4 or just after 4. I am delighted that it is a day earlier. The last few days I have been busy working except for today, when I went for a walk with my wife. It was such a beautiful day today. And so until the day after tomorrow. Your short letter gave me such great pleasure.

Your Kan.

MUNICH,
OCTOBER 18, 1902
WASSILY KANDINSKY
TO GABRIELE MÜNTER

My good, dear friend,

On Sunday I cannot come: we shall be having visitors! Confound it!

When you come on Monday don't let it be apparent that we have seen each other more than twice. Yes? Once in school and once at your place yesterday.

Today I was reading your letter again over and over and I got so much from it. So many different thoughts and feelings alternating! Yes, yes! You are right. I think of you now all the time, much more than before, when I paid more attention to my own interests. "You old egotist (me)." I love you very much and again and a hundred times as much. You have to believe it and you mustn't forget it. And then in public and for ourselves we are friends. And then time comes and shows us where we were right and where we were wrong. And we have more trust in each other! Yes? Not always asking oneself: is this Love? Why should I lie? I too have lost my peace of mind, my equanimity. I would so much like to see you for just a half hour! But one must also have a tiny bit of character! And I want to have it. Even though it hurts.

Many regards
Your K

MUNICH,
OCTOBER 27, 1902
WASSILY KANDINSKY
TO GABRIELE MÜNTER

My dear, good, gentle friend, my shy little Ella, I read your letter and in spite of everything I read between the lines that you love me. And the feeling strikes within me such a tender chord, as tender as you yourself. And I think of you all the time and see

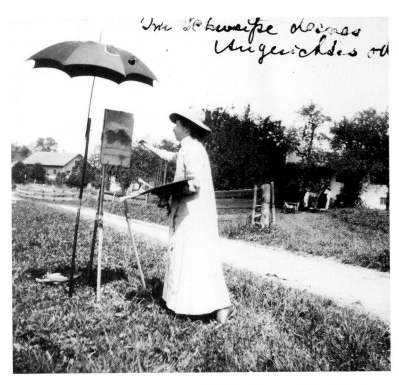

17 Gabriele Münter painting. Kochel, 1902

your darling little face so clearly before my eyes. Your kind face, which I should like to see much, much more often than I in fact can! I can appreciate that it is not easy for you to make the decision to come and visit us....When can we meet again? Our visitor arrived today, and now I really don't know when I will be here....Perhaps on Thursday again in the Hofgarten? Around 1/2 past 6? However I cannot promise definitely and if I don't come my dear Ella will be angry with me again. She is always angry with me! Or will she still come? Wait for me under the arcades from 1/2 past 6 to 1/4 of 7. Yes? Oh, yes! Please, please, please: — The two hours we have together at your place always fly by so quickly. There is no time to ask questions or say anything. It only occurs later what one wanted to know and talk about....Goodbye, my Ella, my gentle friend. I am thinking *a lot* about *you.*

P.S. The enclosed scrap of paper is my poem translated into German [not included], which serves very well to show how carefree I still was in July. And then I lost my peace of mind. But

41

better for me to lose it than you. "Ya liubliu Tiebya" [Russian: I love you]. Do you still remember that?

<div align="right">Your K.</div>

MUNICH,
NOVEMBER 21, 1902
WASSILY KANDINSKY
TO GABRIELE MÜNTER

Since you left me in Theres.str., everywhere: at school and now at home I have such a feeling of peace and happiness in me. From time to time the thought reoccurs to me: but she said she was not very sorry, although she knew it was over now. A bitter thought, which grieves me. But (conceited fellow!) not for long. I don't know why I am so sure that I play more than just a minor role in your life....I believe it for the reason that I esteem you very highly and have a high opinion of you. I still have the feeling: she wouldn't have let herself be kissed if it was all just a game for her. That's not the way you are, dear heart. Deep down in your noble nature you are too pure, too honest. I am not usually wrong in these matters....How I would love to see you again, if only for 1/2 an hour! Yes, patience, patience, — better times will come our way. Oh, how good it was today to hear you say "forgive me!" How tender your dear voice was. And how happy you can make me. And how you can hurt me! And my heart is ever more attached to you. In spite of everything! — Good night, good friend, dear Ellchen

<div align="right">Your K.</div>

MUNICH,
DECEMBER 9, 1902
WASSILY KANDINSKY
TO GABRIELE MÜNTER

My dear, good friend, my good little heart of gold, if only you knew how happy you can make me! My heart is still jubilant, you were so good, so kind, so nice to me yesterday. Words are too pale, too feeble, too shallow. I think of you all the time, I remember the wonderful hours you gave to me. Of course, you also had hard words for me, but, I must be frank, the hard words evaporate, disappear amid great joy. I still hear it as if you had only just said it, that "I love you." And you were so tender, and so affectionate. Perhaps you have reproached yourself again, perhaps you again said, "that was the last time," perhaps you again thought to yourself that I mean nothing to you. I am almost certain that I do not deceive myself in this. And it grieves me. But at once it starts up again, the memory of your face, of your eyes, Ella, and my heart is glad again. How you can make me happy. And how you can torment me. Dear, dear, dear Ella. Do you know that "Ella" in Italian means "she"? And you are my "she" you know, who holds my heart in her dainty,

tender hand. . . . And believe me and think of me often, very very much. When I am in the middle of working I hear your dear voice, I feel you as if you were there. The old fool! No! In two days time I will see you again, though it be as strangers, distant. I kiss over and over your dear hands and each finger, the lo-ong finger.

<div align="right">Your K.</div>

You wanted to regain your peace of mind, you wanted to free yourself from me by that abominable speaking and behavior. All in vain! You can't get rid of me that easily. Perhaps you don't love me very much, but you do love me, that I know. Very well! I propose the following: for a time we will be just good friends, no carrying-on in secret, when I visit you I will be good, will not breathe a word about love. And time will tell how things stand with us. But I do this for love of you, you must know that.

<div align="right">Your friend K.</div>

MUNICH,
DECEMBER 11, 1902
WASSILY KANDINSKY
TO GABRIELE MÜNTER

Only a few of Münter's and Kandinsky's letters have been preserved from the years 1908 and 1909, which saw an important and productive period in Murnau. Nor do we possess any other personal documents from Kandinsky or the couple's artist friends that might shed light on this period, whose significance for art history is also considerable. All the more valuable, then — and an incomparable source of information about the entire history of the Blue Rider group — is the account that Münter wrote retrospectively in 1911, providing vivid insights into many episodes of these years. She compiled this chronicle, partly written in diary form, on May 17, 1911, when Kandinsky had gone away for a few days to visit Franz Marc in Sindelsdorf. Münter had started to keep her "book" several years before, after the tour of the Rhineland and Holland that she and Kandinsky had undertaken in May and June of 1904, and continued it in August 1905, when she was staying with her sister Emmy and her husband in Bonn. The section headed "Munich. No. 36 Ainmillerstr. Rear building 1. May 17, 1911" contains some of the best-known references to the history of the Blue Rider. It is published here in context for the first time, with only a few minor details omitted. The chronicle ends with an account of Münter's stay in Murnau in the fall of 1910 and the contacts with Franz Marc, which played such a key role in the events of 1911, at the time of writing.

Well then, Rapallo 05-06

Paris 06-07

Berlin 07-08 spring Lana

summer Munich — fall Murnau. Summer 1908 I stayed Pension Stella 48 Adalbertstr. — also winter 08-09 — and in winter had studio nearby 19 Adalb. IVth floor. With the good Miss Mathild as housekeeper. From fall onward K. lived at Lechleiters' — 36 Ainmillerstr. rear building.

We had seen Murnau on an excursion and recommended it to Jawlensky and Werefkin — and they asked us to come there in the fall. We stayed at the Griesbräu & liked it very much.

After a short period of agony I took a great leap forward, from copying nature — in a more or less Impressionist style — to

◁ Detail from fig. 19

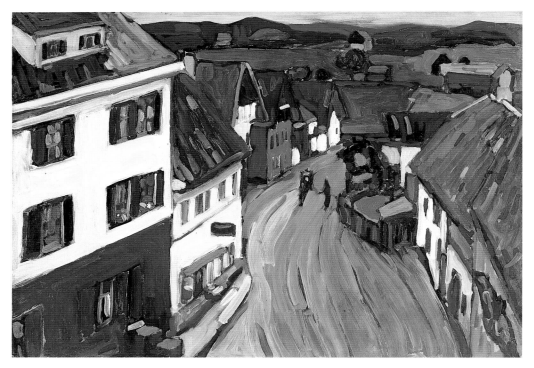

18 Wassily Kandinsky, *View from the Window of the Griesbräu*, 1908

feeling the content of things — abstracting — conveying an ex-
tract.

It was a wonderful, interesting, enjoyable time, with lots of
conversations about art with the "Giselists," who were full of en-
thusiasm. I particularly enjoyed showing my work to Jawlensky
— who praised it lavishly and also explained a number of things
to me — passed on what he had experienced and learned —
talked about "synthesis." He's a good colleague. All 4 of us were
keenly ambitious and each of us made progress. I did a whole
heap of studies. There were days when I painted 5 studies (on
33 x 41 [cm] sheets of cardboard) and many when I managed
3 and a few when I didn't paint at all.

We all worked very hard.

Since then, Kandinsky's work has progressed miraculously.

Then fall 08 Murnau I

Winter 08-09 he Ainmiller me

Adalbert 48 I and 19 IV

Founding of the *Neue Künstlervereinigung München*. Kandinsky
decided to take over the chairmanship as no one else was in a

46

position to. Met and became friends with Fanná Lebssantsch Hartmann and Mrs. Olga Arcádina.

In the winter (or late fall) he [Kandinsky] dictated to me — one day when he was feeling very off-color and so we didn't go to one of the first meetings of the Association — the first — composition for the stage (Black-White-Colored)

In Feb. we went to Kochel to see the Hartmanns. We traveled Garmisch first — from there sleigh Mittenwald — and in the hotel there we also worked on his compositions (Mittenwald was lovely in the snow!) Then by sleigh to Kochel! In Kochel 14 days or so with the Hartmanns. Together with K. Hartmann sketched (very interesting, very talented) the music to the "Giants".... This work came to nothing — although K. took a great interest in it and had a small stage (c. 60 cm) podium made for rehearsals. & had designed all the sets (and for a fairytale, too).

The baroness appeared less than enthusiastic about the collaboration & friendship of the 3 — Sacharoff Hartmann Kan-

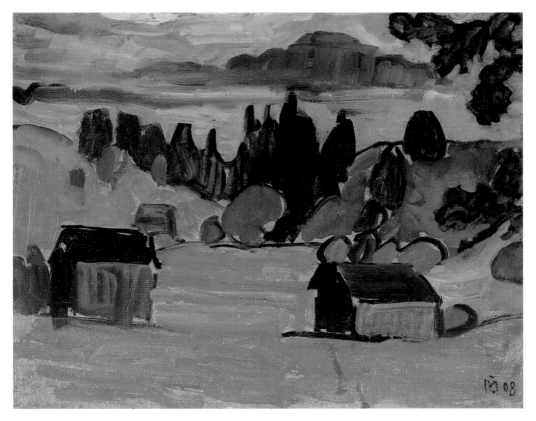

19 Gabriele Münter, *Murnau Landscape*, 1908

20 Gabriele Münter, *Houses in Murnau*, 1908,
pencil sketch

dinsky. Sacharoff began to lose part of his initial interest in
the work....

Spring 1909 the Giselists rented for us the apartment next to
theirs in the Volksbazar at the Echters' house. With one break,
we were there until June — then we moved to stay with Xaver
Streidl — in the newly built villa that Kandinsky had fallen in
love with at first sight. To this love he has remained faithful.
There was a lot of debate — he put a certain amount of pressure
on me — by late summer the villa had been bought by Miss G.
Münter. The vacation the Schroeters were in Murnau. Friedel
already a sweet, nice, big girl of 6. She liked to play with Gustav
— he enjoyed playing the role of suitor — and she particularly

21 Murnau,
ca. 1909. Photo-
graph by
Gabriele Münter

22 Wassily Kandinsky, *Street in Murnau (Houses)*, 1908

liked putting wreaths on her head and would dance and play
the princess. Of course she also became very attached to Uncle
Wass. End of Sept. the Schroeters went home and we to Munich.
With Prasselsberger moved the things from 36 II to 36 I then
father Kandinsky came (he was also with us for months when we
lived in *Sèvres* — he stayed at the Tête noir in Bellevue and was
at our place every day) stayed with us in K's studio and stayed 1
month or so....

I've had enough of this. So to cut things short. Fall 1909 Oc-
tober our first club exhibition at Thannhauser. Since Oct. 1909
we have been living here together. 1910 spring nice couple of
weeks in Murnau — looking after trees and garden. Then again
late summer or fall. Summer Munich. 1910 — stage II — at
Thannhauser initially. in the upper rooms this time.

K. was 2 mths. or more late autumn — first Moscow then
Odessa. 2 days in Petersburg for the divorce.

From June on we had the younger sister of the Hartmanns'
cook — Anna Gruber.

For 1-2 weeks — when K. in Russia — we were with Hedw.
Fröhner in Murnau in Oct. — was nice. Fanny Dengler has now
been with us since February. Kandinsky had always wanted. Be-
cause of her mother's illness she came back from America —
where she had apparently very much enjoyed it.

Today K. went to Murnau (Wednesday) to visit Marc — our
splendid new friend — in Sindelsdorf and discuss things and
mainly to be alone and relax (until Friday) — and I — as I
didn't feel up to working — sat down to get on with this book.
Perhaps one day I'll also do the chronicle of the Association?
[i.e., the NKVM] — They were interesting and edifying years on
the whole....

Emmy long ago invited me to visit them in Berlin. Now we're
planning to go to Murnau next week with Fanny for 8-14 days
and after that I want to finally make up my mind and go visiting
in Bonn, Herford, Berlin.

23 Gabriele Münter, *Outskirts of Murnau,* 1908

Our life is very hectic — very busy. We don't get around to a
lot of the things we'd like to. A few days alone helps to save
time. Want to get a lot done the next few days. And hope he
enjoys himself a lot and refreshes himself somewhat.

*In a note (dated February 10, 1933) for Johannes Eichner, Münter
goes into more detail about her discovery of traditional Bavarian
glass painting.*

K. & I, you know, were — I think spring 07 [1908] in Tyrol —
saw there lovely painted wayside shrines & the like. Traditional
folk art. But glass paintings, I seem to remember we first came
across them here. It must have been Jawlensky who first drew
our attention to Rambold & the Krötz collection. We were all
quite fascinated by the stuff. At Rambold's I saw ... how it was
done — & I was in Murnau — & as far as I know the first in the
whole group to get panes of glass & do something too. First

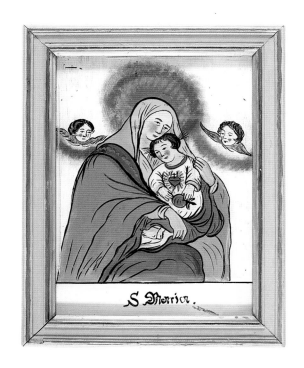

25 Gabriele Münter,
 St. Mary,
 1908-9,
 glass painting

copies — then various things of my own. All my collections of glass paintings are now in boxes here. I was entranced by the technique and how well things went & was always telling K. about it — until he started himself & then did a lot of glass paintings. In Sindelsdorf, Campendonk painted ingenious glass pictures with tinfoil, gold, silver paper etc. Marc, as far as I know, only did a few. A head [of] Henri Rousseau after his self-portrait, which I think he gave to K. I don't know of any other glass p. by Marc. Old Krötz took a few of my glass pictures for his collection in exchange — an old street in Herford & a crucifix in landscape — not good stuff. They tell me I did some good ones of my own. *Perhaps* they are in my boxes.

There is also a short but interesting note (which Münter probably wrote at about the same time) concerning the sources of inspiration for her art of the Blue Rider period.

If I have a formal model — & in a way that was certainly the case 1908-13, it is no doubt van Gogh via Jawlensky & his theories. (His talk of synthesis.) This cannot however be compared with what Kandinsky was for me. He loved, understood, protected and nurtured my talent.

52

In January 1957, at the age of nearly 80, Gabriele Münter wrote a reminiscence concerning a picture she regarded as particularly important: The Blue Mountain *of 1908. The final version of this painting has unfortunately been lost. In his book about Münter, Johannes Eichner discusses her account of this episode, emphasizing her sensation that she had painted the picture like "a bird that had sung its song." This was later cited as evidence that Münter's style was a naive, involuntary statement not based on any form of plan or reflection. However, Münter herself points out that she has no such recollections about the painting of other pictures. When seen in context, her account provides a further insight into her collaboration with Kandinsky and their fellow-artist Alexej Jawlensky during the Murnau period.*

Reminiscence. I recall the little picture *The Blue Mountain* as if it were a very special experience. I once (perhaps no more often than that) went out with Jawlensky [alone] to paint landscapes. J. had stopped back on the road to Kohlgrub & was painting — I had gone on a little farther and turned off slightly to the right on the way up to Löb. Then I saw the Berggeist inn down be-

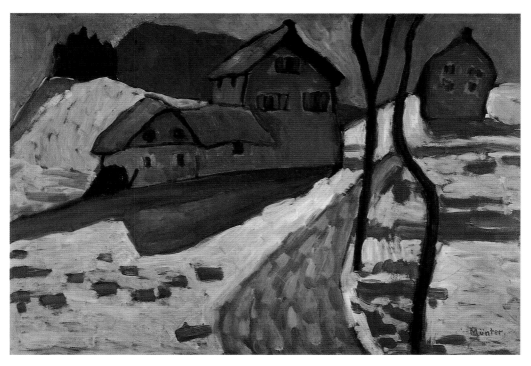

26 Gabriele Münter, *Winter Landscape*, 1909

27 Gabriele Münter and
Olga von Hartmann.
Kochel, 1909

28 Gabriele Mün-
ter, Thomas and
Olga von Hart-
mann, hiking
in the snow.
Kochel, 1909

low & the way the road climbed up & the blue mountain be-
hind & little red clouds in the evening sky. I quickly sketched
the picture that presented itself to me. Then it was like I woke
up & had the sensation as if I were a bird that had sung his
song. I didn't tell anyone about this sensation, I am not a very
talkative person anyway. But I kept the memory for myself. And
now, so many years later, I am recounting it. Otherwise, when
painting, I did not make self-observations of this kind. The pic-
tures were simply there & are there. Nor did Kandinsky speak
of such things. But I noticed that there were some of my pictures
he particularly loved & found interesting. The landscape with
church, the blue lake, landscape with sunflowers, landsc. w.
white wall, mountain landscape with pines, the straight road,
country house near Murnau — are some that come to mind.
(Mostly 6f sheets of cardboard ["6f" refers to the standard for-
mat — 13 x 16 inches — for open-air oil studies] & bigger sheets
of cardboard & canvases). The country road in winter too (large
sheet of cardboard) I painted that in Mnch [Munich] & Jawl.
happened to drop in — again he was kind enough to "wilt" with
enthusiasm. In Murnau once he was with Ka when I came home
with painting on cardboard. This was our first year in Murnau.
When J. saw the study he cried "A thousand marks!" (at that
time I would have sold my studies for 50 M. if anyone had
wanted them — but I never thought of selling, I was collecting
studies & learning). That study was a view from the "Alpenblick."
Meadows & branches in the foreground, of which Jawl said "eye-
opener."

54

29 Gabriele Münter, *Tombstones in Kochel*, 1909

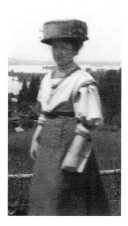

30 Gabriele Münter
by the Staffelsee
at Murnau, 1908-9

Perhaps the first person to buy anything from me was Hedwig Fröhner.... Sometime or other I suppose (perhaps as early as 1908 or later, in Murnau, she saw studies I'd done). She bought 2 studies off me for her brother, the dentist in Zurich. From the proceeds I bought 2 pairs of skis at Lodenfrey's. & we slid about a bit in the snow in Murnau. but as I had no one to instruct me I took a nasty tumble & soon gave up.

Letter addressed to "Fräulein G. Münter, Murnau a. Staffelsee (Oberbayern) Gasthof Griesbräu." Kandinsky wrote it while moving into Ainmillerstrasse in Schwabing, where after years of being constantly on the move he finally made his home, initially in an apartment on the second floor. Kandinsky briefly interrupted his stay in Murnau for the move, during which he also had Russian relatives visiting him.

MUNICH,
SEPTEMBER 4, 1908
WASSILY KANDINSKY
TO GABRIELE MÜNTER

Dear Ellacken, I am sitting in my apartment, writing on the window ledge, awaiting the furniture in vain. It's a good thing Behringer sent sofa and armchair: that means I have at least a nether support....

So I am coming back tomorrow evening and possibly we will both go to Munich on Tuesday (if the Ksidas don't come to Murnau). I am satisfied with my apartment and the studio is not as dark and small as I had pessimistically imagined. Today it is dull and yet bright. I am going to town now to eat and return here in the afternoon. How are you? Is it drizzly there too? And you can't paint? Going to see Epstein as well today. Evening at Anja's.

Many fond greetings and an obedient kiss on your little painting-paw.

Your Was

In December 1908 Kandinsky spent a few days in Urfeld and Kochel with the composer Thomas von Hartmann and his wife Olga. From Urfeld he sent an effusive postcard to Münter, who was staying at the Pension Stella in Adalbertstrasse. In a postscript, Thomas von Hartmann alludes to the weeks they were planning to spend together in Kochel in February of the following year.

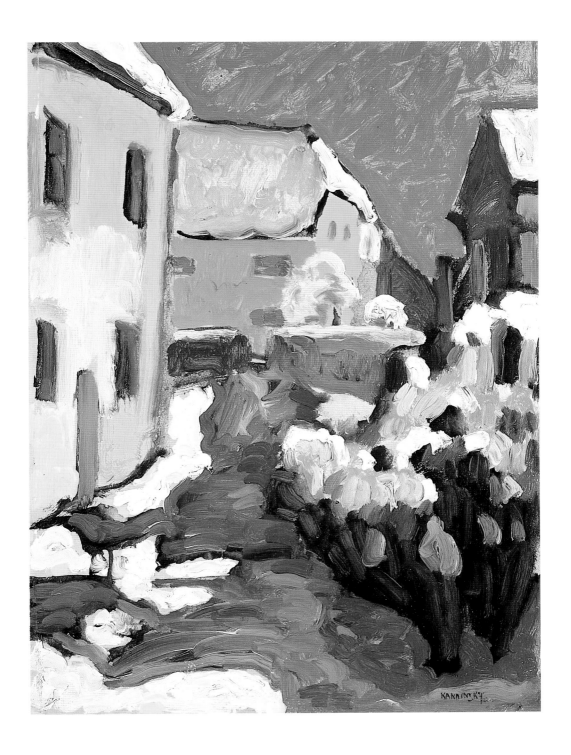

31　Wassily Kandinsky, *Kochel — Graveyard and Rectory*, 1909

URFELD
(WALCHENSEE),
DECEMBER 10, 1908
WASSILY KANDINSKY
TO GABRIELE MÜNTER

Urfeld

Infinitely capital weather and hair-raisingly beautiful! Would you be so kind and bring for the two Hartmanns *one* undershirt each (thin silk).... Many thanks in advance and looking forward to seeing you soon. Your K.

Postscript in Thomas von Hartmann's hand:
Thanks in advance.
Kind regards. Can't wait for Kochel. Th. Olga Hartmann

Since Kandinsky and Münter still had separate households in Munich, their meetings often had to be arranged by letter.

MUNICH,
EARLY 1909
WASSILY KANDINSKY
TO GABRIELE MÜNTER

Dear Ellchen, Schnabel [Dr. Heinrich Schnabel] just came calling but I did not see him. He is coming again at 1/2 past 1. No doubt we have to go to the courthouse, something in connection with the statutes [of the Neue Künstlervereinigung München]. I feel better today, but my head is playing up & like it was stuffed with cotton lint.... But I can come and see you at 5 or earlier. Just tell Fanny what you would prefer. If you could come to my place, that would be marvelous. But I don't want you to overexert yourself. As I say, I can come to you quite easily. Many fond greetings

Your W.

32　Gabriele Münter, pencil sketch for *Jawlensky and Werefkin*, 1909

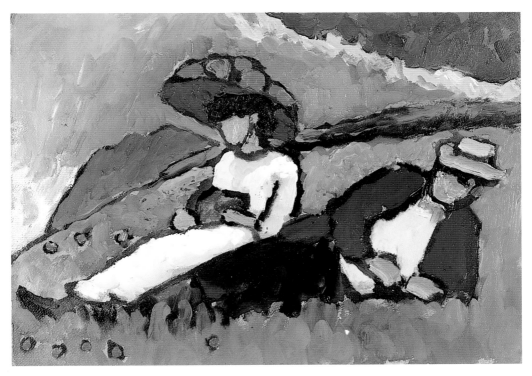

33 Gabriele Münter, *Jawlensky und Werefkin in the Meadow*, 1909

In her recollections written down in the 1950s Gabriele Münter also has something to say about music, which had been an important part of her life throughout her childhood and early youth. She continued to play the piano during her stay in America, but in subsequent years music took a back seat. The following extract refers to the year 1909 or thereabouts.

The music teacher in Munich might well have made his lessons more interesting if I had had the sense to show him what I had already attempted in the field. It was silly of me. Th. v. Hartmann would have been a good opportunity, — but I didn't think of myself & my musical wishes at all & anyway I would have been too shy to approach Hartmann, although I'm sure K. would have backed me up, for he appreciated my musical bent, & would not have discouraged it, even though he did not respect my love of dancing & stifled it completely.

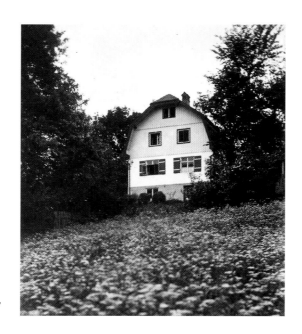

34 The "Russians'
House" in Murnau,
ca. 1909

Letter from the Pension Stella in Adalbertstrasse, where Münter also had her studio.

MUNICH,
FEBRUARY 6, 1909
GABRIELE MÜNTER TO
WASSILY KANDINSKY

Evenin' dear, I don't know yet whether to go to the studio again this evening or to read Müller here. There is no particular reason for me to stay here — but I'll probably stay at home after all, that is just take the letter to the post. I wanted to remind you — don't forget to send the camera to Amalienstr. tomorrow & to order *how many* cassettes [containers for photographic plates] are to be hired. I would say 2 — then with our 2 cassettes we can make 8 exposures for 2 pictures — that's 16 photos. Enough work for one day.

Hand-delivered by messenger.

MUNICH,
APRIL 5, 1909
WASSILY KANDINSKY
TO GABRIELE MÜNTER

Well, dear Ellchen, how are you? If you are confined to bed *I* will come to you of course. But if you are still up and about will you come to me? and when? I didn't stay in bed after all, but have been lying around the whole morning — sofa, armchair, ch[air] — drew a bit, not much, apart from that continued reading the enthralling Sue story. I am rather under par, not in a good mood, have a thick head. The wind is terrible. In case you are confined to bed, I have enclosed an envelope, and you can

tear off half of this paper for a reply. — I would like something, but what? I have a yearning — but for what? I don't even know myself. I feel like the figures in my pictures.

I tenderly kiss your dear hands.

<div align="right">Your Was.</div>

In 1909 the couple spent several weeks with Jawlensky and Werefkin in Murnau; at the end of June Kandinsky went to Munich for a couple of days to attend to various matters. Münter wrote the following letter immediately after his departure.

Hello dear, got home all right. It is still pouring with rain & there have been a couple of peals of thunder. I am reading....

The rain is stopping & I shall soon put on woolen stockings & take the letter to the post. No great urge to work at the moment, perhaps later. Already ate a lot of fruit.... Haven't seen Dre[sler] yet.

Best regards! Hope you will write as well & let me know that you arrived safely. Alas you forgot the madonna!

MURNAU,
JUNE 26, 1909
GABRIELE MÜNTER TO
WASSILY KANDINSKY

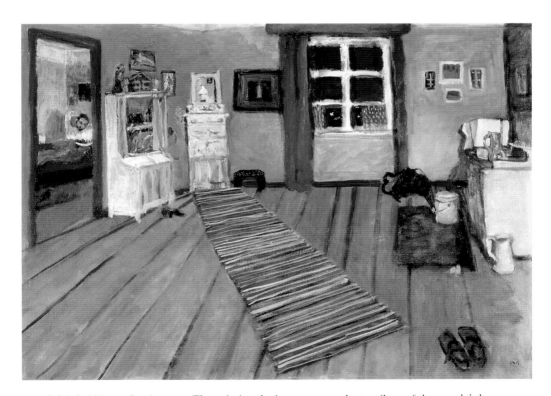

35 Gabriele Münter, *Interior*, 1909. The painting depicts rooms on the top floor of the couple's house in Murnau

36 Alexej Jawlensky, Marianne von Werefkin, Jawlensky's son Andreas, and
 Gabriele Münter. Murnau, 1908-9

*Letter addressed to "Fräulein G. Münter, Murnau a. Staffelsee,
Volks-Bazar," where Münter was staying with Jawlensky and Weref-
kin. Kandinsky tells how he was visited by colleagues from the Neue
Künstlervereinigung München. The greetings to the Murnau "col-
ony" would no doubt include — besides Jawlensky and Werefkin —
Emmy Dresler, Münter's former fellow-student at the Phalanx school,
who was there on a visit.*

37 Emmy and Georg Schroeter, Gabriele Münter's sister and brother-in-law,
 with their daughter Friedel. Murnau, 1909

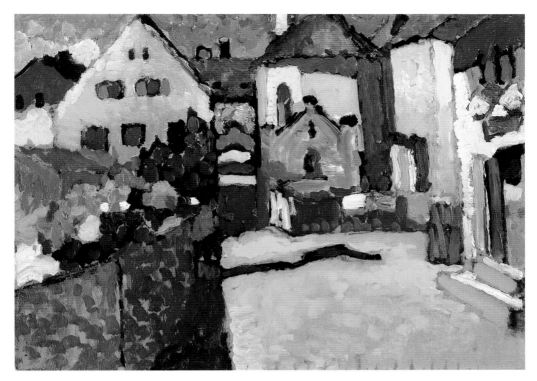

38 Wassily Kandinsky, *Murnau — Grüngasse*, 1909

Dear Ellchen, I am very cross: forgot madonna! forgot time-table! How did you get back? It absolutely poured down. How are you? I felt sad to leave you alone in your present frame of mind. Just take things very easy....

Schnabel was here just now. He said he nearly drowned sailing with Kanoldt, and suddenly changed the subject to my article in the M. P., started railing at me and acted like a very old camel. I gave him the right answer. Enter then: shaven-headed Erbslöh (splendidly shaped skull!), in tuxedo and Dr. Wittenstein also in evening wear. Now I sit here and think: who is the cleverest of the trio? And I don't know. No! I don't know. At any rate Dr. Sch. and E. send their regards to the Murnau colony....

Be good, healthy and moderately industrious, but only do things that are splendid. Much love, darling, and see you again the day after tomorrow.

Kind regards to the whole community. Your K.

MUNICH,
JUNE 26, 1909
WASSILY KANDINSKY
TO GABRIELE MÜNTER

MURNAU, MOSCOW AND
MUNICH: 1910

In October 1910 Kandinsky traveled via Weimar and Berlin to Moscow, which he had not seen since 1903; a month and a half later he went to visit his family in Odessa, where he stayed until shortly before Christmas. Münter first spent some ten days in Murnau, and then remained in Munich. It was the first time in five years that the couple had been separated for any length of time, and they wrote to each other on an almost daily basis. In their references to each other's letters it should be borne in mind that the mail service between Bavaria and Russia generally took about four days.

My dear, it is 1/4 of 3 — your telegram has just come — you arrived safely in Berlin then. Yesterday evening around 12 I suddenly felt afraid that something might happen to you — I read for quite a long time after that to get sleepy & get rid of the unpleasant feeling & was nervous & often woke up during the night. As it takes such a long time for a letter to arrive — I sent a telegr. this morning to enquire how the journey to Berlin was. Your letter only came with the 3rd post around 12 & I am again quite sensible and content....

 A short letter from Fröhner....She will be glad to come to Murnau — 3 days with him — have to fix a date with her the next day or so.

MUNICH,
OCTOBER 11, 1910
GABRIELE MÜNTER TO
WASSILY KANDINSKY

By now you will be rattling on your way again & I just want to send a quick letter so you'll have one when you get to Moscow....Managed to have a word with Fröhner in the Eng.[lish] Garden & arranged that we will travel to Murnau on Monday — she for 8-14 days & he for 3 or so. Hope the weather holds out....She is looking forward to it....If I hadn't started the ball rolling it wouldn't occur to me just now, but I am sure it will be very nice and pleasant out there. Fröhner is such a dear.... Spent the whole evening yesterday tidying up my desk. Painted this morning and then for a *quick* walk in the Engl. [Garden] to work up an appetite — it took a whole hour, as I did some quick jottings in Seestr....So I haven't been to see anyone yet about

MUNICH,
OCTOBER 12, 1910
GABRIELE MÜNTER TO
WASSILY KANDINSKY

65

◁ Detail from fig. 39

painting. Have more time & inclination anyway to paint than to go out visiting....

And you are moving closer and closer to the border of the German fatherland — don't stay too long.

MOSCOW,
OCTOBER 14, 1910
WASSILY KANDINSKY
TO GABRIELE MÜNTER

So here I am, my dear, dear Ellchen. It's already 1/2 past 11 (9 for you) & I am tired, but I want to write you a few words before the day is ended....Well, the journey continued capitally: compartment to myself from Warsaw to Moscow & had a good sleep. How this whole atmosphere affects me! I'll tell you about it later in more detail. But how Russian and yet also un-Russian I feel! How some things almost move me to tears and some things make my heart beat louder. How different the people are. Why is life here...more intense and gripping?...Every city has a face. Moscow — 10. And a bit of everything. It is uncanny, it affects one. How will the old religious art affect me? Shall I find the core that I want to seek, to touch?...Do be very careful & good & cheerful, dear friend. And a nice good night.

Your old Was.

How would Moscow affect you! &?

Postscript from next day, October 15, 1910:

Now I'm going out. Sunshine. Kremlin spires glistening. I'm practically delirious. Moscow is — whiplash. Moscow is — balm. Next time you must come too. Lots and lots of love, my dearest.

MOSCOW,
OCTOBER 16, 1910
WASSILY KANDINSKY
TO GABRIELE MÜNTER

My dear Ellchen, still not a syllable from you! & today is Sunday to boot, so it's hardly likely anything will come. It seems like a hundred years since I heard from you. What can that mean? I wanted to telegraph, but forced myself to be sensible....I got back home at 1/2 past midnight & ... back from the H's [Hartmanns]. So we spent 13 hrs. together. What fine, great, almost tempestuous joy that was. The sweet little lady kept saying, "You, you here! It's so wonderful." And Tomik kissed me over and over again. No, but perhaps this is one friendship that will not fade away. And the warmth and affection with which they spoke of you. And they send you their very kindest regards. So we talked & talked & couldn't get enough of it....This morning I

39 Wassily Kandinsky, *Murnau with Church I*, 1910

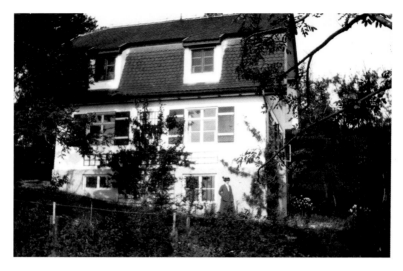

40　Gabriele Münter in front of the "Russians' House," ca. 1909

am writing letters. Then at 1 lunch with H's at the famous "Praga" (my student tavern), then Shirinev's for tea and at 6 dinner with the Scheimanns....If only I knew what you are doing, how you are, dear, distant friend. All my very best regards, my dear. — Don't keep me waiting for news. Your Was.

In the evening of the same day Kandinsky writes again:

I have just come home & at last found your letter of Wednesday eve., so that was the 1st I got here....I am very glad that you are working with such perseverance on one job....

Well, this morning wrote & read letters. Lunched with the H's at 1 (mm...mm...mm... what a meal at the "Praga"!), then strolled a bit together & took photos in the hurly-burly of the streets & talked about the club at the H's....

Do go and see Anja, Ellchen! But probably you will be in Murnau from tomorrow on. I am addressing this to Munich, though, as I'm not sure....A good thing it is so warm: you won't get wood in Murnau straight away. Here it is also glorious & in the sunshine Moscow is terribly beautiful. It was like a dream in the Kremlin today. All the solemn religious paintings on the facades & the domes! And the view of Moscow's "Bogenhausen" [one of Munich's leafy suburbs].

Just 2 words today, dear Ellchen. I'll wait for breakfast & then get started. In 4 days' time (Saturday evening) I have to give a lecture before a distinguished audience: 20 people mainly musicians, then painters, philosophers etc. It was of course Javorsky who arranged it....

I must work hard. The weather continues to be brilliant.... So I imagine you are also having good weather & are now in Murnau....

Then at 12 we stepped out again to the Kremlin in the moonlight. I have always been crazy about that. I went to bed at 1 but could not get to sleep right away. So for now lots of love. I am still enchanted & continually flabbergasted! Perhaps now I won't be writing absolutely every day. So don't go imagining things! Right? Keep well, good, content & make progress in art at every moment. Regards to Anna.

<div align="right">Your Was.</div>

MOSCOW,
OCTOBER 18, 1910
WASSILY KANDINSKY
TO GABRIELE MÜNTER

41 Wassily Kandinsky, *Garden in Murnau*, 1910

I'm trying to think of a nice Russian phrase as salutation — now I can get on with writing: I wanted to write at the table in the dining-room with Fröhner & I didn't want to write a German salutation & felt generally embarrassed. Well, my only dear darling — good evening! What are you doing, how are you? Please let me hear from you tomorrow — else I shall get so bored.... 3:45 we went to Murnau....Had a look at the street, lunched, chatted, had a look round house, your pictures....Then we had a nice walk to the lake & along by the fences through woods finally onto the road near Berggeist so that we got home for supper at just half past 6 after which Mr. A. went home via Munich. I got up early today, too — before 9, we looked round the garden, Fr.[öhner] gave a lot of kind advice.... Then we went up the path from the garden & finally arrived at the Lourdes grotto — picked lots of meadow saffron & came upon a big bush in the meadow that was bare of leaves but deep red with little seeds — the sky was deep blue and it was suspiciously warm. We both slept in the afternoon, then tea & preparations for painting & when at last we got going a storm blew up. We painted at the far end of Burggasse & just then all the Murnau cows came along & I had to jump over the ditch out of their way. Did 2 studies — not bad — not good. Not in the mood today, no fire or spark. Perhaps got up a bit too early.

— G'morning! 1/2 past 9, just got ready & waiting for the samovar. I'm working quite hard now. The day after tomorrow at 8 p.m. I have to give the talk! But only finished the 1st half. It's going quite well though....

 — I am totally in love with Moscow. The former beauty is now complemented by all kinds of conveniences....And what still never ceases to caress me — the general friendliness....And it is beautiful, Ellchen, indescribable. We still have impeccably beautiful weather and moonlight. The streets in the moon and elec. light are like magic....I'm very curious about Saturday & ...nervous. I haven't seen any painters yet. All that next week. Now to write & write! Much, much love, my old Paint-Ellchen. Be cheerful, healthy, happy, energetic. And give my regards to the Fröhners & Anna. Glad you went to see Anja. And...do write, please! Voyons, madame!

Your o-old Was.

42 Gabriele Münter, *Boating*, 1910

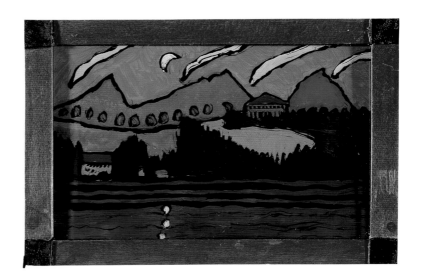

43 Gabriele Münter,
Murnau —
View from
the Lake, 1910,
glass painting

MURNAU,
OCTOBER 23, 1910
GABRIELE MÜNTER TO
WASSILY KANDINSKY

My dear Was, on the 18th I got first letter from Moscow, which was written in great haste on the 14th — you had already visited several people & were already full of Moscow. Then on the 21st here in Murnau I got one addressed to Munich that was writ. on the 18th. — in it you write (also as hastily & skimpily as you can — I haven't yet received a real proper letter) that you have to give a lecture on Saturday (yesterday) and that it was of course arranged by "Javorsky." It's the first time I've heard the name. What sort of lecture? I don't know. Has one of your letters got lost in between? I would be content if you would just once write a proper letter & let me know if you were getting my letters. ...It really is a pity that you can't spare just a quarter hour so I know something about you. Practically in the time it takes you to send me a scrappy note that doesn't leave me any the wiser you could give me some proper news if you put your mind to it.

There is nothing much happening with us. Fröhner does her needlework — I potter around in the house or garden & laze around & feel generally bored. We'll be back in Munich again this week. Please write to the Munich address anyway. The first few days the weather was lovely, now it is dull. I'm too lazy to do anything. Just wanted to tell you that I have grounds to be displeased with you. — unless there was a letter that got lost.

Your Ella

Dear little beasty, darling foxy-woxy, thank you so much for your No 8.... — Yesterday we (Tomik and I) went to see Goncharova. She was rather cool at first (that's the girl who wrote the rude letter). In the nicest possible way I gave her a piece of my mind (she is very young), which made an impression, as she was happy to show a lot of pictures, which I took the liberty of criticizing (very gently). *Very* talented things, with a *lot* of feeling, in a word *very* interesting, though a bit too theoretical on the one hand and not fully worked out on the other....When we left she shook my hand warmly in student fashion. Today I went to see Demisov, who is not coming back to Moscow from the country until next week....Just received your scolding letter of the 23rd. I am very sorry that you are in a bad mood, which you take out on me. Altogether I sent you 9 letters and cards from Moscow, at least 2 (or 3) of them addressed to Munich, in which there is also more about Javorsky. I write to you a lot & at length, not "scrappy" notes. You write to me a lot less & in fact more "scrappily." Voilà Ma'me!

Javorsky is a pupil of Tanejev & a splendid fellow. He has shaken up the whole theory of music & established new principles (drawn from the oldest). He has pupils, doting admirers & many enemies, as is always the case in such things.

<div style="text-align:center">Your Was!</div>

MOSCOW,
OCTOBER 26, 1910
WASSILY KANDINSKY
TO GABRIELE MÜNTER

Been here now for 14 days. Just had breakfast & in rather gloomy mood. I don't know where I got it from. Nerviness, need to make a decision whether to go to Petersburg (waiting to hear from Ratner), lack of time, desire & need still to attend to so many things.... hectic, precise wants — sell house or not ... and finally, longing for you, my Ella! My God! That's reason enough when you come to think. My mind can never stay in balance for any length of time & it's not just big weights but little gram particles tip the scales heavily downward, so that the other pan flies skyward. — You are right, my Ella, I am not responsible for my actions & so often mean, sharp, hard & absent. I too long for balance of mind, for a peacefully fragrant life with you with a lasting inner harmony of our minds, our bodies. But there is always "someone" or "something" coming along and laying his finger, his fingertip on the pan & the balance and harmony are gone....How *incredibly* kind *every*one here is to me, Ellchen.

MOSCOW,
OCTOBER 28, 1910
WASSILY KANDINSKY
TO GABRIELE MÜNTER

Wherever I go, really, I hear that people cannot forget me, that an old bond stretches from the old days to the present, and can feel that I am different & that they have to take a different stance with me than with others. And I sense this bond all the time and the contact with these old friends and acquaintances is melodious. Why is this so? Sometimes I despair of this injustice, of the misjudgment I undeservedly (so very very undeservedly) receive from people here. Munich is immensely beneficial to me, being so little liked there....

How strongly I wish for you to work and for what you create to be ever more splendid. — That's all for today. Tenderly and with pure love I kiss your hands. Regards to Anna. Is she being good? Your Was

You are bound to find the missing letter from me in Munich.

MUNICH,
OCTOBER 29, 1910
GABRIELE MÜNTER TO
WASSILY KANDINSKY

My dear, dear, good Was, I am in a terrible hurry to write to you. I should really like to telegraph.... Have just come home to Munich & found 2 old letters from you in the mailbox — am all of a flurry & very upset — firstly that I gave you such a fine old scolding & 2ndly because the whole time in Murnau would have been so much nicer for me if I had not been so disgruntled as I did not get a proper letter from you.

I came home just now and found the mailbox full, although I asked the concierge & she promised, if there should be anything in the box, to send it on.... Yesterday was the only day that I was lively & functioned & painted. Found myself wanting to the day before & we resolved to work with gusto — & yesterday we really did. Today the entire day devoted to the journey — got up at 8....

Fröhner too — I am to tell you she "congratulates you on *such* a property in *such* surroundings!!" She was quite enchanted by the house & its situation & all of Murnau & its situation. We had some marvelous days, too. But even when it was misty there was so much of beauty — & today it was beyond compare. Air like the time we went up the Herzogstand with the Hartmanns. From my window I saw each tree on the hill this side of Kochel & I found it really hard to tear myself away.... And today it was hot! on the 29th of October! Mrs. Streidl said it was the good wind, sun-wind. The sky was *so* blue — & white, thin wind-clouds. The mountains in shadow were *such* a dark blue — & in the sun everything clear. The starry sky last night just as beautiful.... I did 2 studies in the morning and 3 in the afternoon, 2 good

74

studies, 1 study & 2 poor studies. Our little house is one of the former. Out of this world. Fröhnerl was a dear & always had stories to tell. A capital person. I already told you that we also made ourselves useful in the garden....So was in Murnau 1 1/2 weeks, from Tuesday evening–Saturday afternoon. The Streidls are well, did their kitchen blue with oil-based paint like ours....Mr. Rambold came to ask advice about an arrangement with the shop run by the Verein für Heimatkunst. We were not in — so we went to see him & Fröhner gave advice & we had a look at the things he had done — she purchased a little picture for which, reasonable as ever, he only asked 50 pfennigs. He walked us home then & I believe asked to be remembered to you. The Streidls as well, I am sure....It is really awful that it will now take 4 days for you to get this. And without those 2 letters there was *such* a *big* gap in the sequence! And I would have felt so totally different. I was not at all cheerful & didn't feel like doing anything. I see that I very much need to be treated nicely.

44 Gabriele Münter, *Landscape with Church*, 1910

My spirits seem to have lifted then after your letter the day before yesterday. I began to feel like painting & suddenly saw things again. Fröhner also did a couple of studies.... Many kind & affectionate regards! My one and only darling,

your Ella.

So don't be cross, will you?

MOSCOW,
OCTOBER 29, 1910
WASSILY KANDINSKY
TO GABRIELE MÜNTER

My dear heart, just to say goodnight. Have just come from Lentulov's (the painter I turned down). Found his nice wife at home first. Then painters kept dropping in: Konchalovsky (Le Fauconnier's friend), whom I will see again the day after tomorrow at Mashkov's, Goncharova, Lari[o]nov, a few more painters & finally the man himself.... Today, however, it came to light that they were having a meeting about the exhibition on 1/14 [Russian and German dating] XII, to which I and Jawl. are to have invitations sent to Munich. I talked about Marianne. Then of course I withdrew so as not to intrude....

It is 1/2 past 10, I shall go to bed, want to get a good night's sleep for once. Tomorrow first church, then lunch with the Hartmanns. Then Goncharova. Then go to an exhibition of toys.... Then dinner with Abrikosov (him) and Tolya Scheimann at the "Praga." In the evening something theatrical. And now goodnight, my dear, my dearest.

MUNICH,
OCTOBER 30, 1910
GABRIELE MÜNTER TO
WASSILY KANDINSKY

Good Sunday my sweet dear!
Munich life has begun already. I wish I could write to you or be with you the whole day. What shall I tell you first? Anna took my letter to the post office yesterday evening, but the 10 o'clock collection had gone. Today I wired after all — I don't want you to be angry so long. So it seems the whole thing was my fault.... There would be so much to see here — (*your* pictures — *mine* — the things on the *walls*) to think — to do — to read (first of all newspapers). I have put away my studies so as not to be distracted by them — first I'm going to work on couple of sketches (paint pencil jottings) & then there are still lifes asking to be done wherever you look — It's *so* beautiful here with the flowers! And the table with the 17 madonnas!...Well I was very silly & weak to let myself get annoyed & not to suppose that there might be letters waiting here. It probably won't happen again but still let us systematically number them so that we know

76

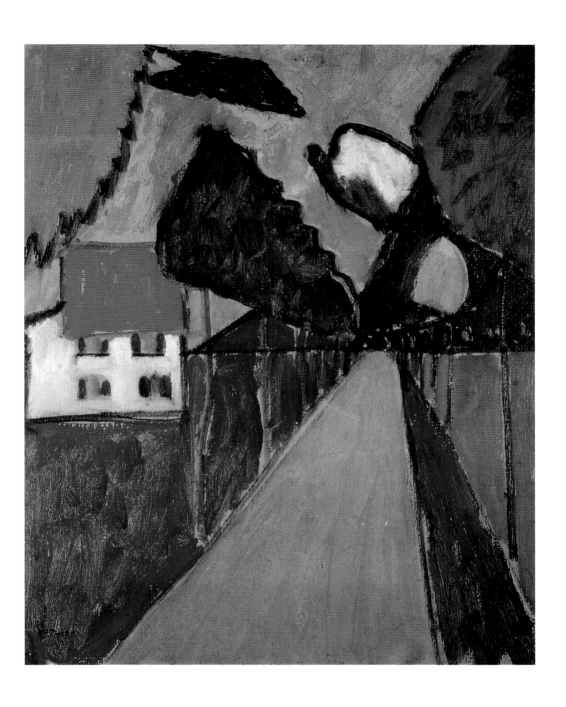

45 Gabriele Münter, *Kochel — Straight Road*, 1910

46 Gabriele Münter, *Haystacks near Murnau,* 1910, pencil drawing
from the artist's sketchbook

47 View from the
"Russians' House"
in Murnau,
looking south
toward the Alps,
ca. 1910

where we are. Your letters are now so nice & kind & full of news as they used to be. You know, if you hadn't been cold & often not nice to me more or less the whole of this year it would undoubtedly not have affected me so deeply — but in the end it looked as if you had changed toward me, as you no longer seemed to want to write to me as you used to, at length.... Want to take up Fröhner's suggestion that we should go to theater etc. your father says, "young people need to enjoy themselves." Yes, when one is beginning to get old, one emphasizes & likes to feel that one is *still* young. I don't think I need to "enjoy" myself all that much — it has never been a large part of my life — I should be content just to be treated kindly! e.g. Now with your letters I am very content — you always used to be like this when we were together & you have simply spoiled me — so you will just have to carry on. I am naturally *very* pleased about (Eat it right away, folks, before it gets cold!) (continuing in the afternoon:) your successes & the lively good life in Moscow....I *very* much hope things will proceed as we agreed, that you are now enjoying Moscow to the full — making new contacts, cultivating old ones & then visiting your parents & arranging things so that you come back to me by mid (Europ.) Dec. Is that still the plan?...You would have loved it in Murnau, titmice & crossbills (rarities) sweet darling little birds always at the sunflowers &

78

the squirrel was terrifically busy. The climax was the final day yesterday. You could see every little hut on the Peissenberg — we had no idea they were there. And everything was beautiful, immensely....And you continue to have *lots* of pleasure & success & fun! How much longer are you going to be there? Don't hurry, but don't come home too late!

Much love! Now let the 2 of us be friends again!

Your Ella

Worked at home yesterday morning, mainly writing letters. Tolya came for me at 1 & we walked briskly to Shirievs', Mrs. Scheimann was there too & we were served perfect blinis (pancakes), of which I indulged in approx. 10....Then a short break for tea & to Mashkov's where Konchalovsky also came....

Finally I was asked yesterday to compile a list of our people (of my own choice) so that the invitations could be sent....For your choice (or your pictures for here) I have already compiled a provis. list & await tomorrow's talks to make alterations in it & send it to you.

MOSCOW,
NOVEMBER 1, 1910
WASSILY KANDINSKY
TO GABRIELE MÜNTER

Münter refers to Kandinsky's letter of October 28.

Just read your letter, my dear good Wassi — but you should not be sad & annoyed, my dear sweet one. That comes from rushing around. You don't have to rush yourself, really. On the one hand try to be more ruthless & only do what is most necessary — & on the other, if you can't manage everything you want to do in such a short time I shall have to prolong your leave, like it or not. I think of course I will feel very sad spending Christmas without you — but you mustn't tear yourself apart for the sake of 2 weeks earlier or later. Just keep well, then you too will be in good spirits. And allow yourself one *complete* day of rest.... Yesterday morning town, got back home late, tired, hungry. Had tomato soup & potato fritters — perhaps ate too much & was finished for the rest of the day. In the evening, when your card had been dispatched I went to change & was undoing my bodice when it occurred to me that it would be much nicer to stay at home — & I didn't like the thought of possibily seeing acquaintances in a possibly empty (museum) hall — so I stayed & painted a landscape & went to bed early. Now I really have a mind to work again & have a lot of plans. A landscape in autum-

MUNICH,
NOVEMBER 1, 1910
GABRIELE MÜNTER TO
WASSILY KANDINSKY

79

nal mood on which I want to work in earnest. This morning I painted over the first sketch from yesterday evening. Am doing more of these, have to find line & color — perhaps "synthesis" too!...Going to see Anja now, could not receive her yesterday because I was too exhausted & had just sat down to dinner. Today Fröhner is coming in the afternoon.

Received your darling letter yesterday afternoon & only read it in the evening & this morning again more thoroughly....So for the time being just to say hello and many many thanks for the kind letter. How sensitive you are, my Ella! I am so terribly sorry that Murnau was spoiled for you thanks to the stupid concierge. But you shouldn't be so sensitive. You know how much you mean to me, how I love you sincerely & deeply & properly notwithstanding ("notwithstanding," that is, my bad character). & you should trust me more and think: something has happened — that's why there are no letters. I also have to tell you that I was & still am *totally* engrossed by Moscow & the impressions here....So until later, then. I kiss you from all my heart with pure good love....

Now all our 8 from Munich will be invited by me to take part with 2 jury-free works in the "Bubnovi Valet" exhibition in Dec. I enclose a registration form for you....The Hartmanns insist on letting me use the dining room as a studio. They are kind & good to me in every way: when I arrive tired I must at once lie down on the sofa & Olga pushes a nice cushion under my head. Tomik puts my legs on the sofa and I *must* sleep. So think well of me and be *very* patient with me! You dear, pure one. Your Was.

What would you say to celebrating Christmas tree together with the Schroeters in Berlin? I think it would be nice — then we would stay until beg.-mid January! That sounds nice to me — what about you? Sooner or later I'm going to have to visit the Schroeters — Emmy keeps pressing me!...Early this morning in bed I was already drawing — a still life that I painted yesterday evening (from Murnau.) then your letter came, then up early & painted 3-4 hours — until lunch. First finished painting a still life (large) I'd drawn yesterday — dark, impressionistic — mystical — paaainted — kitscheee. My armchair table with lots of madonnas and flowers. Then the same again small from the other side — synthesis — then lunch — then redid yesterday's

48 Gabriele Münter, *Still Life with Figures,* 1910

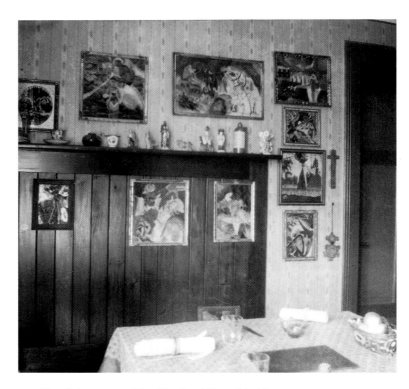

49 The dining room of the "Russians' House" in Murnau, 1910

still life more stringently following the morning drawings. & when I came home this evening I did another drawing of it — unmistakable Picasso influence. Am enclosing sketch & preliminary drawings.

MOSCOW,
NOVEMBER 5, 1910
WASSILY KANDINSKY
TO GABRIELE MÜNTER

With the "Beluga" (a plain but capital fish) I also got the sweetest letter of 1.11. N 15. I thank you so, so much.... Much quieter time has now begun anyway. And it's not the rushing around that's responsible, but the shattering impression of Moscow (not like Jawl. saw M. as *city*, but M. as a whole in every respect). Now I have at least grown somewhat acclimatized.

MUNICH,
NOVEMBER 7, 1910
GABRIELE MÜNTER TO
WASSILY KANDINSKY

Yes indeed, as you see from my letters — I'm painting [in orig. "penidre," i.e., "peindre"]. As I find very good the study Kochel straight road, I plan to send it to Moscow at any rate. However as I cannot make it better I have copied it larger — as accurately as possible — but the small study is still better. But I wanted to

have another copy....I was awake early today after 7 & got your card later at 9 I fell asleep again and got up at 12! After breakfast painted — new still life my madonna table again.

Despite my running around I do think about art a lot. At the moment I'm still at the infant stage. I couldn't paint anything right now. The impressions are still too strong, too confusing. Larionov told me about the command in the army & I was quite shattered. I should like to paint that sort of thing, give the inner sound form-color. — Very much love, my treasure, my wife and friend. Your Was.

MOSCOW,
NOVEMBER 8 (7), 1910
WASSILY KANDINSKY
TO GABRIELE MÜNTER

 Very glad that you are often seeing Anja.

Kandinsky refers to Münter's letter of November 3, with the suggestion that they should spend Christmas together in Berlin.

No, no! I am going straight home from Odessa....Anyway it is time to come home. I would like to digest all the impressions and do some painting. For this reason I am very much against Christmas in Berlin. And a shame to celebrate such a wonderful occasion in that vile city. Sooner Murnau. In the middle (or toward the middle) of January we'll go there Berlin for 14 days, which is quite enough — to my mind. Let us stay alone & together awhile after my return & best of all in Murnau. I would like to see Anja again as well. That would mean no end of traveling!...Do you agree?...I am quite delighted at your persistent efforts to find drawing. I like the sketches. Now as you know I am quite opposed to hard, overly precise form, which "today" is impossible & anyway leads to a dead end....If you really feel what I mean (don't philosophize, just *simply* understand, feel!) you will also find form. One must let the form work on one and forget all the Picassos and Picassore....Work! Don't overdo things! Be healthy! Feel! Keep at it! And lots of love from your old Was, who is missing you.

MOSCOW,
NOVEMBER 8, 1910
WASSILY KANDINSKY
TO GABRIELE MÜNTER

In the morning, after retouching my pictures, I went for a fitting and to do some shopping — dreadful weather! Painted in the afternoon. Factory! And now I have cast the madonnas to the winds — there's been enough of that. Am putting a lighter-colored cloth on the table to get a different picture....

MUNICH,
NOVEMBER 8, 1910
GABRIELE MÜNTER TO
WASSILY KANDINSKY

I am very displeased that you are burning yourself up like this. Do hope things will be better in Odessa — it would be desirable at least. Today I was at first not really in the mood — the piano woman in the house opposite who plunks away on the piano all the time with the window open — put me out of temper — & anyway there has to be a reaction after working like mad. Then Lulu [Jawlensky] came — I showed what I had done — He was lavish with praise — he stayed for luncheon....When Jawl. had gone I took a quick look at the newspaper — it was getting dark by then — walked a *little* in Engl. Garden, which was still full of people....& then I was a long time at the Kanoldts'.

Kandinsky spends a few days in St. Petersburg to attend to the formalities of the divorce.

MUNICH,
NOVEMBER 12, 1910
GABRIELE MÜNTER TO
WASSILY KANDINSKY

My good, sweet dear, today you must have a letter again. I have nothing much really to report, apart from a bit of toothache — felt slightly cold yesterday & there it is already in the little tooth, you know....If you come just before Christmas we can have a little tree here & go to Murnau for New Year's, so we don't have to rush things right away! Or would you like at all costs to go straight to the villa?...Your letter of today that you number 26 dated 26/8.X.XI is in fact 28. You are such a terribly dear fellow! But it is still a long time until you get back & I am not going to let the time drag on, but work....

— Let's try and plan our time. Work on our own a lot & yet be together — going for walks & so forth!...It was the *scheme* of the lines I was drawing & it's all experiment — anyway. I am sure you are aware that I never think how does so-and-so do it or how did I see it in this or that picture.

In two long letters dated November 13 and 15 Münter had told Kandinsky about Alfred Kubin paying a visit to Ainmillerstrasse and apparent friction between her, Jawlensky and Werefkin at a concert. She had also talked about her toothache.

MUNICH,
NOVEMBER 16, 1910
GABRIELE MÜNTER TO
WASSILY KANDINSKY

The Giselas [struck through] Marianne [von Werefkin] seem to have something against me — but I am not aware of having given cause for offense — thought about writing a letter to clear up misunderstandings – but I shall watch things for a while &

let them make the first move....At the concert on Thursday eve. Lulu [Jawlensky] promised to come by again on Friday, but didn't....My lips are peeling after the temperature it seems I did have after all over the past few days. As Fröhner didn't come till quite late yesterday I did quite a lot of painting — this afternoon I did the village str. w. geese larger, did the sketch yesterday. In some ways better — in others worse than the study.

MUNICH,
NOVEMBER 17, 1910
GABRIELE MÜNTER TO
WASSILY KANDINSKY

If there really is some hidden hand that has been obstructing the divorce up to now & you believe this — will it now go through? It seems to me that if you had been in Pbg [Petersburg] sooner yourself, this would have happened anyway. You must tell me more when I see you. You know that I trust you & your feelings, despite not always being there with you....

Today we were alone all day and I may say I almost got bored. In a way I am quite well — in another however not — I lack the energy to get on with anything properly....

To return once again to the rather strange behavior of the Giselists — I am somewhat perplexed — has Marianne suddenly gone off her head?...The Bar.[oness] had at any rate been acting differently toward me for some time. I made one or two minor faux pas with her, but I certainly didn't mean to offend her and I can't believe she would be so petty as to take umbrage at such things — impossible. For Jawl. to make himself scarce — quite likely that when all is said and done it was *nothing at all!?* If I ask them for an explanation. him particularly. I asked him in Murnau to be frank with me, and tell me if there was anything he was unhappy about. Anyway — I have done no wrong & I'm not going to make the first move. They can go hang, for all I care.

50 Kandinsky in Murnau, 1910-11

Münter had also told Kandinsky of Kubin's opposition to the Neue Künstlervereinigung München.

MOSCOW,
NOVEMBER 18, 1910
WASSILY KANDINSKY
TO GABRIELE MÜNTER

Kubin is not altogether right. A club like this is a useful thing & we do have the most interesting German painters in our town. What is one to do if there are none better? I keep hoping that our people will become more serious and accept their great obligation. Then the works will get better too. A club is a spiritual force. In Paris & here too it is only individual forces (as always just a few artists) which of course working together create a

denser atmosphere.... Regards to Anna. What about the teeth? I am very worried about your tooth. Mrs. Abrik sends you kind regards. I had to tell her a lot about you.

MUNICH,
NOVEMBER 18, 1910
GABRIELE MÜNTER TO
WASSILY KANDINSKY

Well, my dear, now it's all over. I went to see v. Br. [von Bracht, the dentist] — he wanted to cut & pull without further ado — but I thought the time was not yet quite ripe & he said all right, let's wait until tomorrow. But then when I got home & it was still hurting I thought that's enough of this & sent Anna with a note to him that he should put me out of my misery today after all — he sent for me at half past 4 & I was in the chair at 5. I was already very nervous & did not put on a very good show.... Must say I don't really feel like visiting the Kanoldts — but didn't know what excuse to make when they asked me recently to come round one evening. Have to repay the Kaspars' visit as well — & find it rather boring.... That's enough for now my dear, I shall be frightfully glad when you are here again. Much love! Your Ella. Despite the pain I chattered away so much to Anja yesterday that I forgot to pass on your regards. Next time.

MUNICH,
NOVEMBER 19, 1910
GABRIELE MÜNTER TO
WASSILY KANDINSKY

My dear, I got up just now, before 9 p.m., couldn't summon up the strength earlier. Now I'm going to write, and ask for my bed to be made. How fortunate that I dealt with the tooth business yesterday! Today I felt not too bad and not too good.... Anja came after dinner and brought flowers — but she left without seeing me.... Jawl.[ensky] talked endlessly about things he had bought from junk dealers.... So as I suspected there was *nothing* wrong at all — I don't know — it was perhaps just a mood or a fancy.

MUNICH,
NOVEMBER 20, 1910
GABRIELE MÜNTER TO
WASSILY KANDINSKY

I'm afraid I have nothing amusing or pleasant to tell you. Everything would be all right — nobody disturbs me, lay in bed again till afternoon & was able to rest fairly well — if I could only banish the thought that it was unnecessary & wrong to have the tooth pulled — now I have an ugly gap at the front & will now have to have a false tooth made after all.... Yes indeed — still nearly 5 weeks until you come — until Christmas — and you've been gone a long time already — it's much nicer when you are here, you know — without you I am so much less — you belong

51 Gabriele Münter, *Landscape with White Wall,* 1910

to me so much and make me rich and it is empty here without you. As long as I am working I scarcely think of it. Be always cheerful and well and don't overdo things! Regards to all Muscovite acquaintances & to the Ksidas.

Your Ella

I was in the Shchukin gallery yesterday with the Hs [Hartmanns] for nearly 2 hours. There were other people there as well. The gallery is capital: Monet, Pissaro, Renfrelli, Degas etc., big selection of Gauguin, a few good van Goghs, marvelous Cézannes & finally a lot of Matisses, even very recent ones. I spoke a bit & all right. I also convinced Sh. that he *must* buy some of the very latest Picassos, which he was reluctant to do. He thought it over & said very kindly, "You are right." I sent Sh. our catalogue the same day. He said immensely nice things about Tschudi & is himself a pleasant, agreeable fellow....

MOSCOW,
NOVEMBER 21, 1910
WASSILY KANDINSKY
TO GABRIELE MÜNTER

87

I am thrilled with your latest work: landscape, still life & Simo-novich [a still life with figure]. You have taken the bull by the horns again. Just carry on that way, my sweet darling.

Kandinsky refers to Münter's letter of November 17 and the supposed friction between her, Werefkin and Jawlensky.

MOSCOW,
NOVEMBER 22, 1910
WASSILY KANDINSKY
TO GABRIELE MÜNTER

Let them have their moods if they want, darling. Let us do our duty to our fellow man as best we can & not worry about the consequences. All right? Of course I trust your feelings. — I am scared to death that you got Bracht to pull the tooth!! It would be a great, great pity. What makes me really happy is your rela-tionship to Anja. If I am so cheerful here, so young (as they all claim), such a "bridegroom" (youth) (as Mr. Abrik. said yester-day), if I am such a "jolly good fellow" (as Mrs. Abrik. said yester-day) etc. etc. then one of the main reasons, the main causes, is this feeling of happiness. And the business with the divorce was inevitable, it had to turn out that way — I *know* that now quite clearly (before I only vaguely *felt* it). You trust the "powers" too and let everything "ripen." The right fruit will then come "auto-matically"....

Lots & lots & lots of warmest, warmest, warmest, warmest greetings, my-y-y Ellllla.

Your Was.

MUNICH,
NOVEMBER 22, 1910
GABRIELE MÜNTER TO
WASSILY KANDINSKY

Well, not much to report today. Up quite late & finished paint-ing the still life — It didn't turn out at all like I intended — stupid, no inner life, not beautiful, not right....

There is not much of interest in my letters to tell the Hart-manns! They are nice and long & don't say anything. There are quite a few minor things I should like to get done & never get around to....I very much hope you will be here again no later than 17 — *perhaps* even a little before! But first have a good journey to Odessa, happy & healthy. Heartfelt greetings and kisses, my dearest. Your Ella

MOSCOW,
NOVEMBER 23, 1910
WASSILY KANDINSKY
TO GABRIELE MÜNTER

So you did have your poor tooth pulled after all! I went through everything with you when I read your darling letter in bed yes-terday. Card 31 (received at the same time) reassured me at least — that you don't feel the tooth any more. But it is still a pity! I

am sure the gap will be completely filled up in time as the neighbors move together. Now you are at least rid of the endless pain. Right, darling? — I am also glad that it was probably your imagination after all as regards Gisela & that Andre [Andreas, Jawlensky's son] is better again.

As in several previous letters, Münter writes at considerable length about her dental problems, and now very much regrets having had the tooth pulled.

Had a visit from the Baroness [Werefkin] in the late afternoon — everything is all right — she knew nothing about it — had been looking after Andre & was with him the whole time. Told me that Mr. Mark [Franz Marc] had been to see them with a Mr. & Mrs. Macke from Bonn, whom the Müs [Münter's brother Carl and his wife in Bonn] apparently also know. And plenty of other news too....

Well, that's it. I have gone and filled nearly 8 pages again — but I just don't know anything & you are much too kind to yawn about my petty concerns — aren't you? I really feel bad about having continually mentioned the stupid tooth business — I'm sure it must bother you. But anyway it's all right again now. It's just the long reports that are to blame, the habit.

MUNICH,
NOVEMBER 24, 1910
GABRIELE MÜNTER TO
WASSILY KANDINSKY

I'm glad about the way you praise my works — & I believe I have grasped something in the lines (& in color too).

In my case it is largely or nearly always a smooth flow of the lines — parallel — harmony — in your case it's the opposite, the lines collide & intersect in your work. This landscape I did today is like the ones Jawl.[ensky] has painted (or perhaps how he used to, not any more) but as I see it Jawl's are always cruder — coarser — & naked color & form (& *perhaps* generally *stronger*)....

Hope you are well! Take care! Have a good journey to Odessa & keep smiling! Hope you find all your people well & — just get done with them quicker! So you come back at last. Just think how nice it is in Munich! And our lovely villa!

And me! Much love and best wishes!

Your Ella.

MUNICH,
NOVEMBER 25, 1910
GABRIELE MÜNTER TO
WASSILY KANDINSKY

89

The Abriks finally treated me to a meal with the Ksidas & Tolya in the "Praga." We really gorged ourselves & guzzled the drink: vodka, bubbly, cognac. Finally drank tea at the Abriks' & had a good old chat.... I am so very sorry when I think how you have suffered because of the tooth & your regret is my regret that I did not telegraph: don't do it! — Now I think the neighbors ·will come to the rescue and conceal the gap, as happened with me. If not we'll buy a little tooth. Right? — That's all for today. Much love, and an affectionate kiss, you dear thing. Regards to Anja, Daisy, Anna.

<div align="right">Your Was.</div>

Today I have a proper case of ennui, dear. I don't feel like doing anything & don't know what to do with myself. Perhaps after all I will go and have dinner with the Fröhners so as to have a little pleasant company. I still can't get over my tooth & hope you will say something to cheer me up....

Maybe I'll go and see the Fröhners later — the other acquaintances I don't like so much & don't know well enough to visit. Was going to do some errands but as that can be postponed, I postponed it....Do you do that on purpose, write a card just when you receive one? You always have enough to say for a letter!...Well I have nothing to tell. Don't be angry with me, dear, if my letters aren't very cheerful. You be cheerful & healthy in my stead, then & have a good time!

Much, much love!

<div align="right">Your Ella.</div>

Went to the street market today on my own in the end (Larionov has barrack theatricals; Hartmann has a cold). It was cold...! 12 below 0 & very windy to boot. So I couldn't stay longer than 1 1/2 hours & only bought 2 icons (1 in three sections & brilliant) for 4 R. altogether. There are some nice things to be had there. Didn't spend long looking through pictures & didn't find anything....What are you doing at the moment? Is Anja with you? How long I have been away! How long since I was in our apartment with you! Isn't it? — I may write a few words more this evening. Tomorrow I have to go and see about passport right after breakfast. So goodbye, dearly beloved.

Went to see Lulus [Jawlensky and Werefkin] yesterday eve. Andre is still in bed, now he has some kidney trouble — they say the little fellow is very good & long-suffering. And Lulu was lying in bed on the new chaise longue in the studio....It is such a shame for him with one illness after another. Wanted to stop by again today and ask after them but had such a lazy day!...He [Kanoldt] invited me for tomorrow evening at 8 — the Erbslöhs & Wittenstein are coming....Feel a bit uneasy about it. (I just sent the new blouse & the light-colored dress back to the dressmaker to be altered).

How can you think that your letters could make me yawn! It's always such a delight to hear about everything in detail: what you have been doing, thinking, eating, who you've been seeing & so on & so forth....And how glad I am that time drags by for you without me. For me too it drags and *drags*. I wish I could be with you. Well, I have to stay in Odessa for 3 weeks, so I'll be home again in less than a month. We must exercise a little patience. & of course I don't want to cut things too short with my parents....Yesterday I got a marvelous present from Larionov. After the "Valet" exhibition he is sending me this picture & the Goncharova one. They were both very warm and friendly. At the end when we parted he said, "Sometimes I am so coarse! No? Friends however we will remain. Won't we? And ...I should so like to give you a farewell kiss." And we kissed each other very nicely.

Well, I arrived quite punctually at the Kanoldts' yesterday evening & was the first one there for quite a while, as the Erbs [Erbslöhs] were late. We chatted, ate & drank well, & chatted again. I feel very out of place among people. To my horror Mrs. Erbslöh, when she left quite early, invited me for next Tuesday evening & I didn't have the courage to decline....

Anyway, I thought about it this morning and I shall make a polite excuse to Erbslöh & say we ought to postpone invitations for a while since I am not in a social mood at present....The Es are nice enough, & I quite like Mrs. E, but I don't want to start socializing — *especially* without you. With you I should be glad to....

Now you know exactly what's been happening again. Give me a proper reply to all this! I'll soon be starting to count the days until you arrive. Much, much love, my only dear. Your Ella.

At the end of November Kandinsky arrives in Odessa to visit his family. He writes to Münter immediately, emphasizing once more that his stay in Russia cannot possibly be curtailed, and defending himself against the irritating accusation, leveled in her letter of November 26, that he only communicates when specifically prompted to do so.

ODESSA,
DECEMBER 1, 1910
WASSILY KANDINSKY
TO GABRIELE MÜNTER

I was very pleased to see my parents. It is after all a special feeling!...I can't get away in less than 3 weeks, my love. Even if I find you in bed I will be nice and patient & not "insulted." Or should I come later? We don't know the day for sure anyway. But it will be a great pity if you are poorly & cannot be as glad as I will be to be with you....

And now, as for your ideas that I only send a card on receiving one ("a tooth for a tooth!") I should like to give you a good scolding. Really now! Whatever put such ideas into your head? Of course it's pure coincidence, you...! So once again good, good night. I wish I was with you....

I also wish you were in good spirits, happy & productive. Of course I well understand that our work is sent to try us. I too am now in a fragile mood, all shaken up by Moscow impressions. I simply let things ferment inside me, something is bound to come of it....

Much love, from the heart, from soul to soul, my Ella. Do be cheerful & well & brave!

Always your Was

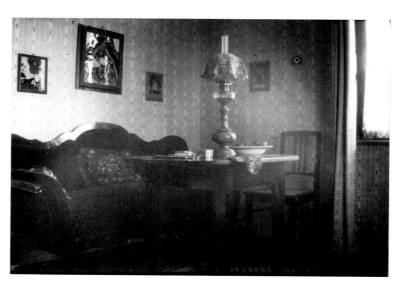

52 A corner of the living room in Murnau, ca. 1910

53 Gabriele Münter, *Still Life in Murnau*, 1910

Good day, dear, dear Ella. From now on, my letters will have a more even tone....Had lunch & continued chatting with mother (father always lies down for a bit). Then tea all 3 of us, after which mother & I went walking & I bought 3 interesting historical books for Mashura & an airplane to assemble for Lilya. In Moscow I arranged that no one should come to the station to see me off but there was in fact an interesting & nice lady there who I had never seen before & who I was supposed to recognize by her large muff and slight stature. (Go on, please be jealous! Please!!). We did find each other and it was Mrs. Cury, a friend of Mrs. Epstein. We talked about art for a whole hour & I was very sorry I had not been to see her sooner.... And again it is the same thing that I was so happy about in presentiment: form is very important, but only as a means to an end, and so it is at the same time nothing. Form can be impeccable, brilliant, and yet worth exactly a half-sou, because it is

ODESSA,
DECEMBER 12, 1910
WASSILY KANDINSKY
TO GABRIELE MÜNTER

93

empty. So long live form, and down with form! You personally needn't be worried: you *must* say something because it is given to you. Just put your ear to your heart and listen! Maybe you should read more. Good things only. And listen inwardly to the sound they make. Then you will be inspired by even the simplest, most banal sentence. Just listen!: "it was a warm summer's day & the clouds drifted slowly over the tops of the trees"... Banal, like an M.N.N. [*Münchner Neueste Nachrichten* — the local Munich newspaper] serial & yet has a resonance. Do you hear it? And this also has a resonance: "I wish I could get rid of this cold." One must repeat it quite calmly in a monotone & listen. The world resonates and is not mute. The ear must catch what it needs. And what it needs is beauty and truth. Thus there is no one beauty & no one truth. But as many as there are souls. Only some are mystic-kindred to one another & resonate at first sight. Ecco la filosofia del arte!

I affectionately kiss your dear, dear hands and your dear, dear lips. Be good, learn to wait, haste not & do not scold yourself when you spend a few days on the sofa. How are your teeth? Give my kind regards to Anja & Daisy. Remember me to Anna.

Your Was.

MUNICH,
DECEMBER 12, 1910
GABRIELE MÜNTER TO
WASSILY KANDINSKY

Yesterday I took a short walk in the afternoon & made 2 jottings & wanted to go to town, but was so sleepy that I fell asleep sitting on the sofa with my feet up. I always want to sleep now & not do anything serious. Get up late. You would scold me if you saw how lazy I am....Anja's last words on Friday were "and you *will* go to the Erbslöhs'!" But I don't want to visit people without you....On Sundays there always used to be someone calling. But now for another picture! Much love & best wishes!

Your Ella.

In this letter Münter goes into some detail about a second evening in the concert hall when Werefkin again hurt her feelings. At the end she suddenly proceeds to criticize Kandinsky's pronunciation of the Russian "l", which was giving her trouble in her attempts to learn the language.

94

So can you be here by the 20th then? If you were not to come at Christmas I would go away — then you can come home to an empty apartment. You must come as soon as you can — not postpone it & keep your promise to be considerate, otherwise, see if I care....But you must learn l for me — I don't like an ii for an l (y for l) your false l is much harder for me as well — I too can say an l like Loulou — at least it sounds the same & that *is* clear.

MUNICH,
DECEMBER 5, 1910
GABRIELE MÜNTER TO
WASSILY KANDINSKY

Yesterday I had to tell mother all about our "estate" in Murnau. Father also wanted to hear about all the changes we had made. If you are a good girl we shall go there for several days right at the beginning of January and get on skis again if there is any snow....

I should like to have a letter from you, right now! What are you doing now? So far away? It's 11 o'clock your time and per- haps you are still at breakfast or even in bed?

ODESSA,
DECEMBER 7, 1910
WASSILY KANDINSKY
TO GABRIELE MÜNTER

My dear, dear Was — could have carried straight on writing to you yesterday after my letter because I had the feeling I hadn't replied nicely to your dear kind letter. But was too tired later after all — after washing my hair I stayed up late — I do that frequently & did something or other, don't remember what.... Should like to buy us approx. a doz. books as well — Just when we are saying that I have to read more — I've known that all along!...But what I'm reading now is not art (novel) but more philosophy and historical. — I need it all. As regards my inner depths, I've already told you you overestimate me.

MUNICH,
DECEMBER 6, 1910
GABRIELE MÜNTER TO
WASSILY KANDINSKY

Kandinsky responds to Münter's letter of December 5, in which she accuses him, among other things, of mispronouncing the Russian "l".

Just got home & read your letter. A bad mood came upon me toward evening today & already been impolite to father 2x, which I am very sorry about. Now you are to get your share. If you can do nothing but find fault with me & always have some- thing to complain about I should like to know why you are fond of me at all. Now I have to learn to pronounce l like Lulu does. Thank you very much, but take the liberty, by your leave, of keeping my l. I don't mind making concessions in lots of little things, but to change my pronunciation would be too quick for

ODESSA,
DECEMBER 8, 1910
WASSILY KANDINSKY
TO GABRIELE MÜNTER

me: it is in fact good. Some people even find the l particularly appealing. But even if it isn't appealing, it isn't so ugly that I suddenly have to unlearn it. Ecco!

Then N 2. Of course I wouldn't like to find you in bed, but in good health. But I am sorry that you speak of my return in such a tone. On the 6/19 it's Kolya's nameday & it will perhaps not be nice if I depart 2 days before. I'll talk to my mother about it. If she feels hurt at this I shall stay till the 7/20 & will be in Munich the evening of the 22nd. You suggested yourself perhaps coming after Christmas & for New Year's. Now you say if I do I will find an empty apartment. You know that I have been longing for you all this time & can't wait to see you. You have now got tired of waiting & start threatening me. I am often very surprised at the things I put up with from you! All those who are really fond of me show me so much love, consideration, tenderness all the time & spoil me so endlessly (& have spoiled me all my life) that the way you act was very hard for me to take especially at the outset & it felt like sticks and stones.... Remember that I was a man who from childhood everyone had spoiled & idolized (I think that word is justified here). The days in Moscow now have taken me back to that old atmosphere. Now however I have grown up enough to feel ashamed when I see this undeserved love (again the word is justified), which is unjust, which pains me. That's the stage I am at. Perhaps, & I hope so, I will grow a lot more. And that is perhaps your mission. You know that in Munich I am not spoiled, not appreciated (in the old days the latter would have driven me quite out of my mind), that I have a hard time there for this reason (since I am just not yet all that far advanced). Why do you want to turn my home sour for me as well? Well, perhaps it is necessary. I mean, to begin with, it would be sufficient if I swallowed my pride & accepted the fact that you love me much less than I love you. Or am I also to grin and bear these "little" pinpricks? I feel very depressed now & the night makes me shudder. It frightens me like those earlier nights when you were asleep & I was tossing and turning for hours & was repelled by you when I came to you in my despair. — Just now I thought I had better tear up this letter, as it will hurt you & won't help anyway. It would however be dishonest toward you & the letter shall be sent....

They can all go hang. I'd like to live in solitude and cast aside life's adversities. Fine! I know it is faintheartedness. I know. But I'm tired, tired of being "magnanimous." In fact I am tired of

many things. I wish I could only live for art. Oh! to beard the "lion"!! I'm ready to beard the lion. It's just that I don't want to have to beard the mouse.

Thick fog today & last night. Did 3 sketches this morning. Painted them all in the afternoon — one twice over. so that's 4. I'm beginning to "sense" something again — (to pick up a scent)....

That's how it is, in another way, with one of today's [pictures].

Just a couple of words, my dear, dear, poor, good Ella. Don't be angry with me for the big, fat letter. I was feeling so down-hearted, so sad & dispirited. If I can suffer so intensely because of you too it only goes to show how deeply I am affected by what comes from you. I wish the sky above us were always cloudless. But as that cannot be let us enjoy the sun after the storm all the more dearly, serenely. What do you think?...

So many, many, many kindest greetings and loving kiss. So the 22nd we'll be together again. If you are confined to bed I will tell you about Russia & the time will fly past.

Always your Was.

Münter's reaction to Kandinsky's reproachful letter of December 8 is relatively calm, compared with the highly emotional tone of her apologies for having complained about Kandinsky's skimpy letters at the beginning of his journey. However, as her letter indicates, she had also received Kandinsky's subsequent conciliatory letter the same day.

You poor thing, were in such low spirits & took offense at what I said about the l. You misunderstood what I meant, or else I didn't express myself clearly. Certainly I think you speak Russian well & I also know that it sounds nice — your kind of l is I am sure just right for you but for me *much harder* to learn than the other. We'll talk that over in due course, all right? You shouldn't be so sensitive! You know it is a failing of mine often to express myself in a way that looks unkind but I don't mean it that way at all. I definitely lack form. Pretty much in every respect....

I am very glad that I also got the good letter today & know that you felt better the next day. And it was also a good thing that you didn't conceal your bad mood from me. Lots and lots of heartfelt good wishes, my only one.

Always your Ella.

Again I *very* much like your sketch. The drawing is probably finer in the picture — I mean just as primitive, but more resonant?...I am now very, very sorry that I wrote you such a harsh letter.

And now lots of kindest greetings and kisses, my Ella. Stay well, in good, productive spirits.

Warmly your Was.

Wrote you this morning & mailed letter at the main post office. I am missing something (you) and I have a desire to occupy myself with you, so here I am writing again. It is half past 6. I also feel dispirited quite often. Life as a whole — & particularly perhaps the main thing — is not as it should be or as at least we would wish. The funny thing is that one manages to see and to feel the bright warm side of things. It seems that when I am alone gloom is much more persistent & the capacity for joy then eludes me more than ever. When you are back here again life will take on a completely different aspect & we will both help each other....

Afternoon painted a sketch from the Engl. Garden yesterday 2x — no good. — & then fell asleep sitting on the sofa again — poor company — then tea later & painted — the potato harvest

54 Gabriele Münter, *Little Green House,* drawing in the artist's letter
 of December 8, 1912

98

55 Gabriele Münter, *Little Green House*, 1910

I sketched in Uffing — not much good — can perhaps use it — & then a still life — good drawing of table in Murnau with tall lamp, flowers & apples — want to paint it up nicely tomorrow....

Wanted to read in the afternoon — the philosophy of the feminist Lessing — a new book "Weib, Frau, Dame" but the phonograph was going across the street with the window open — so I did some sewing and ironing....So much time is always taken up with silly little things — one doesn't know where they come from. I must tell you — I always have my things quite tidy. Just took time for it. One day I started on your table, & want to do a bit more there.

As I already wrote you, I'm coming on the 22nd eve., as I hope to catch the Munich train in Vienna....Is it possible that I shall soon be with you again? Just think of the long, long time we were separated! And now it will soon be over....I shall probably write you just another 5x and then it will soon be the tongue instead of the pen. Heavens, what a lot there is to report, to

ODESSA,
DECEMBER 13, 1910
WASSILY KANDINSKY
TO GABRIELE MÜNTER

99

relate. I hope I don't strain my tongue. I really enjoy telling you & Anja things, you know. But all the others, too!

And now keep well, brave, full of energy, wonderful like you always have been. Mother & father send their kind regards. Father praises you *greatly* for writing so frequently: "Well, she's a good, good girl, that's the sort of thing I like." A tender loving kiss from me, your Was.

MUNICH,
DECEMBER 14, 1910
GABRIELE MÜNTER TO
WASSILY KANDINSKY

Got nothing from you today — why so? Nor have I anything to report. Am lazy — wanted to do some painting — but realized that I didn't really believe in it & broke off after I'd done the drawing. Went to see Anja yesterday late afternoon — only wanted to stay a few minutes & then do a couple of errands in the vicinity — she was just making tea & invited me to have some & I stayed until after 8. Chattered the whole time — I did most of the talking.

ODESSA,
DECEMBER 15, 1910
WASSILY KANDINSKY
TO GABRIELE MÜNTER

Yesterday I went to the Sevastopols' (me the only one informal, all the others tails & tuxedo!) where I met some old acquaintances.... It was quite nice & the people ... are vital, thinking, feeling and gladly listen to things they are not accustomed to. We (rather — I) spoke of art, religion, morals etc. These people are alive. This morning I was at Mrs. v. Wagner's — gymnastics class — 12 children, Mrs. Sevast. was there too. We are *all* dining at Koschs' today.... So, a week from today I'll be sitting in the train & feverishly awaiting the evening. And then I get off it & see you! If you only knew how much I am looking forward to it & awaiting this happy hour. And then we'll be sitting in the cab, your hands in my hands, & riding Ainmillerstr.... We have both been invited by the Burliuki to visit them in the country next year. They are *very* nice. Big, strong & so nice and affectionate to each other & each values the other more than himself. 1000 loving kisses, my only, splendid Ella.

Your Was.

MUNICH,
DECEMBER 15, 1910
GABRIELE MÜNTER TO
WASSILY KANDINSKY

Just a kwik note — have to get off to the lecture right away as I don't have a ticket yet.... For supper I ate so much of the excellent caviar that I had a headache afterwards & no longer felt like doing anything much. Up late today, breakfast just before

12 (without caviar after yesterday's experience) & again couldn't make my mind up to do anything. Then I mended an old mosaic brooch very nicely & then I went to Tietz's — There I had a meat pie & 2 cups of bouillon & then did a little shopping there & at Oberpollinger's & looked for ideas for Christmas.... After tea 5 min. rest — then the doorbell — Bechtejev — we had quite a nice conversation for a fair length of time he was given tobacco & of course some caviar & he left and now I must leave too....

How's it going to be then? When are you coming? Is your brother going to excuse you from his nameday?

Not a single letter from you today, really. Not in the evening either. Well, tomorrow morning let us hope. You will probably get this on Monday?

Talked to mother about Kolya yesterday, then guests began arriving for dinner....

I have achieved 2 things: 1) got Mietze to sing, which my mother called sorcery, since M. hasn't sung for 2 years & 2) got on the wrong side of Mr. Sev.: I believe he thinks I am a bad influence on his wife with our endless talk about art — he secretly wishes she would take more interest in being a mother & housewife.

Turning to Mrs. Sev., M. also sang a German ditty with a moral: Mr. Sparrow has the fun, Mrs. Sparrow has the cho-o-o-ores. — I'll drink to that!...

I can hardly imagine that in a week's time I'll be feeling like an old Municher again. I wonder when the Russ. impressions will begin to wear off & whether they will be well reflected in my art. In point of fact Moscow has always been the cornerstone, the leitmotiv, of my art: the conflict & the contrasts, the displacement, the mishmash, have their real origin here. But perhaps that will all now mature still more. Would that it did! — Just think: I shall be writing to you just 2x more & then instead of a pen — lips, which will find a different, more beautiful law. Now I kiss you only in my thoughts, but just as lovingly & from the heart, my ever true, my dear, dear Ella.

Your Was.

ODESSA,
DECEMBER 16, 1910
WASSILY KANDINSKY
TO GABRIELE MÜNTER

ODESSA,
DECEMBER 17, 1910
WASSILY KANDINSKY
TO GABRIELE MÜNTER

Received your N. 56 of 12 and 13 yesterday. Many thanks for this lovely long letter especially. I wish you were less often in such a gloomy mood. I am so sorry for you when it oppresses you....

So much, much love and many kisses to my dearest, dearest Ella. In 5 days we shall be together. Isn't that wonderful? I am *very* much looking forward to it.

Your Was.

Kandinsky also adds a postscript saying there is every indication that the divorce will be finalized next March.

In previous letters Münter writes at length about her dental problems, which Kandinsky mentions several times in his replies, offering his condolences.

MUNICH,
DECEMBER 17, 1910
GABRIELE MÜNTER TO
WASSILY KANDINSKY

Don't feel at all like going to bed — nor like getting up tomorrow morning! You hope: that v. Bracht [the dentist] "understands me well" — oh, no — he does not understand me! or in other words — he dislikes me just as greatly as most other people do. Simplicity is not well tolerated, though I am friendly and amiable, aren't I? — but even in shops I get the impression that I arouse antipathy — my imagination? [The rest of the letter is not preserved.]

ODESSA,
DECEMBER 18, 1910
WASSILY KANDINSKY
TO GABRIELE MÜNTER

Today the last letter, another short one I'm afraid. This morning went to fetch mother (bought train ticket) and went with her to cemetery. From there to our place for dinner (at 1/2 past 1 today, as the Ksidas are coming today and we'll be having supper at mother's about 8))....

I simply must catch that train in Vienna! And now, my darling pure, darling dear and much much loved, goodbye until we meet! For the last time — on paper — I kiss your hands and lips so sweet.

Your Was.

These are the last two letters from Münter and Kandinsky for the year 1910.

On Kandinsky's arrival, to which she had looked forward so eagerly, Gabriele Münter was unwell and confined to the house for several days. A postcard from Anja Kandinsky dated December 23, 1910, has been preserved.

Dear Miss Münter, I should be glad if you could call on me tomorrow evening with K. I shall be at home from 9 o'clock onward. What a shame that you have caught such a bad cold; one can only console oneself with the thought that it is only a cold and nothing more serious. Yours very sincerely,

<div align="right">A. Kandinsky</div>

At the end of June 1911, Münter went away to spend the summer visiting members of her family. After four weeks in Berlin with her sister Emmy and brother-in-law Georg Schroeter, she went to see relatives in Herford; finally, at the beginning of August, she traveled to Bonn to stay with her brother Carl and sister-in-law Mary. She then spent several days touring the new museums in the Rhineland, where she met various people from the museum world. At her brother's house in Bonn she made the acquaintance of August Macke. Kandinsky spent the hot summer mouths almost continuously in Murnau, and did a lot of gardening. He met Franz and Maria Marc several times in Sindelsdorf and Murnau.

You are sitting in the train now, my poor, dear Ellchen. I think of you often and wish you pleasure and enjoyment from the journey. I, of course, have nothing to report. I just want you to have a greeting from me soon after your arrival. With all my heart (words are always so stupid and feeble) I hope that you feel well in every sense, that you are recovering from me, and are in good, cheerful, free spirits. It grieves my heart (even though I am sometimes able to suppress it) that I make life so unpleasant for you. What's the use of telling you and myself that I cannot help it? Years ago I seriously thought of going to Siberia & freeing the people I love from me. It would be better if these people were to abandon me and I were alone and could do no damage....

I am busy with my woodcuts & will perhaps go out for a while in the evening. Weather good.

So take my wishes deep into your heart, soak them up — then they will help you. I am so glad that you are going to telegraph me.

Kind regards to the Schroeters and to you many fond greetings from your K.

Good morning, my dear — want to write to you without delay.... shall address to Murnau & send card to Munich so you will be sure to get something....And now thank you very much for

MUNICH,
JUNE 26, 1911
WASSILY KANDINSKY
TO GABRIELE MÜNTER

BERLIN, JUNE 28, 1911
GABRIELE MÜNTER TO
WASSILY KANDINSKY

◁ Detail from fig. 56

your kind letter — was very pleased to get something from you yesterday, so soon. But alas you have got it all wrong in what you write. How can you wish to retreat from your people and me — how can you think — that will do any good. How can you think of liberating me from yourself — you know very well my life would be empty without you. Of course it would be better and more pleasant for me if you could see everything in a plainer light. I wish things were easier for you. But to talk of Siberia & freeing your friends is really not sensible. What are you saying? my life is not unpleasant!...If all the people you have were to abandon you now — their place would soon be taken by others — you cannot help but win people's hearts — you know that perfectly well. The wise and the naive are yours — only the stupid & corrupt are unable to appreciate you. So be content, the bad things I get from you are unimportant — you make up for them 1000fold with good.

MUNICH,
JUNE 28, 1911
WASSILY KANDINSKY
TO GABRIELE MÜNTER

So off to Murnau tomorrow, a better letter will wing its way from there....Very glad you had such a safe and easy journey. Cannot however quite believe that you are in B. I hope you feel *very* well there. I picture this and that in my imagination — what you are doing and how you are feeling....I have already finished one woodcut — proof good. Today started the 2nd one (with angel's trumpet).

Yesterday quite a big tin box arrived from Murnau with berries — half of them giants, but unfortunately nearly all squashed. Today ate the damaged ones stewed. Fanny has bottled a whole bucket of gooseberries & is very anxious whether you will approve. As far as I am concerned — good. Today she'll be doing sour cherries....Be *very* content and healthy — totally!

Very, very much love from your stupid Was.

BERLIN,
JUNE 30, 1911
GABRIELE MÜNTER TO
WASSILY KANDINSKY

The less one does, the lazier one gets. Birthday today....It's raining — Keep meaning to telephone Köhler [i.e., Bernhard Koehler Jr., see p. 126]. Don't do anything don't get around to anything — went to Wertheim's yesterday. Berlin is disagreeable — too big! But otherwise I'm quite enjoying myself. This evening there's going to be a little party. Did you get off to Mu[r-nau] all right? How is the garden?

56 Wassily Kandinsky, *Impression III (Concert)*, 1911

Well, sailed in today with pile of luggage (porter Löbl). It was *very hot,* unusual even for Murnau. Went into the garden at once & ate a few strawberries. Then had tea and bared my knees — splendid. Then back into the garden. And this is how things stand. *Not one* berry has been stolen (i.e. not even red currants etc.) The strawberries look as if splashed with thick daubs of blood. The biggest one today was like this [here, Kandinsky includes a drawing].... The bed positively glows — even from afar, there must be hundreds in there. The small ones are also capital, those we thought were wild (or cross-fertilized): they are like this and a really *dark* red. In that department we really are very lucky. Gooseb[erries] poor — small and only a few. Red c[urrants] plenty and good. Raspb[erries] only beginning to take shape, but not so few as we thought: there'll be a couple of lbs at least.... Pot[atoes] very good and large (20-25 cm). Cucumbers — 3rd leaf, healthy. The new seed we planted next to them (forgotten what it is) has come up *splendidly*.... (The strawberry

MURNAU,
JUNE 30-JULY 1, 1911
WASSILY KANDINSKY
TO GABRIELE MÜNTER

I drew is the one we saw when it was already big but still quite green: top right-hand corner, looking from the house.) The grass is tall again....Then I went to Mrs. Streidl's (sends regards!) & bought supper. Watered the garden. Had supper at 8....Short walk along Kottmüllerstrasse (it was very warm), everything mowed almost completely bare. And at 1/2 past 8 started on your letter. Now it's thundering! Don't want to have a storm during the night. Going to bed soon....

Goodnight, dear, dear Ella. I often think what you might be doing. Just be well & cheerful & perhaps a little busy.

Your W.

Saturday

Brief P.S. Only just turned 9 o'clock & already breakfasted, washed, did room & inspected garden....I brought the dwarf plant (nasturtium) with me from Mun. in a tin container. The journey did it no harm & the larger bud is opening. And there are still a lot of little ones too. There is no one in the little nest (gray bird), it is empty. No swallows either. But the starlings are making a mighty hubbub. I'll wait for Fanny to get here before digging and sowing new beds. Today I'm going to do the wood-cut & probably have lunch at the Rose on the lake....Your room is empty — how strange the sound of empty rooms is — frozen, questioning, withholding. They act as if nothing had happened, but one can tell that they know....

Many fondest greetings, my dear Ella. Be good & cheerful!

Your W.

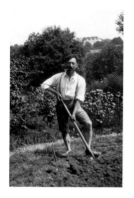

57 Kandinsky
 digging
 in the garden,
 ca. 1910

58 Kandinsky
 by the round bed
 in the garden
 at Murnau,
 ca. 1910

59 View from the "Russians' House," looking eastward, ca. 1910

As for cherries, we will get perhaps 20-30!...Besides the baby radishes, the large variety are also coming along well. In the round bed too everything all right, a few blossoms (the same sort as before). At the top irises (?) — almost wilted. I'll pick black currants tomorrow, so that F.[anny] can bottle them right away as she planned. Poppies with fat buds as high as my waist....A lot of sun today (& then very hot), wind from mountains, so good wea. not guaranteed. Apart from that I worked in the garden a bit yesterday....and mainly did my woodcut (Last Judgment) with great pains and deliberation....Are you going to see Köhler?...Don't forget the Kaiser Friedrich Museum! Don't force yourself to write letters: it's enough for me to know that you are all right. And be a bit lazy if you feel like it. At such times one sometimes makes inner progress....The sun is getting stronger & stronger. All this exhibition business gets on my nerves. And the club! And everything! I just want to do some proper work.

<div align="right">Your W.</div>

Am so sorry you can't pick & eat from the fruitbed.

MURNAU,
JULY 2, 1911
WASSILY KANDINSKY
TO GABRIELE MÜNTER

Good day my precious, how are you? Today received your 1st letter with description of the garden....Now & then I feel just a little bit homesick for you. But otherwise I am fine. I'm being

BERLIN, JULY 3, 1911
GABRIELE MÜNTER TO
WASSILY KANDINSKY

terribly lazy. Yesterday evening I learned the [public transport] routes and wanted to go to the Nationalgalerie early this morning — then I overslept & got up later than ever....Did a bit of shopping, to boost my elegance. Had my hair done as well for once & picked up quite a few hints & now have a better idea of how to do it. Occupation was mostly lazing around and chatting....

Next to the cucumbers are flowers that Mrs. Streidl sent us last day, so all we sowed was large or baby radishes & lettuce — one should sow that from time to time so that one has something to pick all the time. So now, too. Have you transplanted anything? But please don't do so when the sun is fierce. How strange, just one bean....Where have the snails and mosquitoes gone, then? — And my little gray bird? what a shame!...Lots & lots of love & fond wishes.

Let me know what you are doing & thinking! Your Ella.

BERLIN,
JULY 5, 1911
GABRIELE MÜNTER TO
WASSILY KANDINSKY

Yesterday was a busy day. Got up very early, because I didn't want to sleep anymore. Looked around...the Secession. 2 1/2 hrs. solid work, if not more. Hardly missed a picture — I mean looked at them all *properly* — you know how thorough & slow I can be. As for both Corinth and Slevogt, with the best will in the world I couldn't find anything good — artistically better. A still life (flowers) & the Picasso prints I like *very* much....

We were in town in the afternoon & Emmy helped me to buy a dark blue two-piece: jacket & skirt. Tomorrow I have to go for a fitting — to Gerson's! And Monday went to Nationalgalerie.

MURNAU,
JULY 7, 1911
WASSILY KANDINSKY
TO GABRIELE MÜNTER

And congratulations on the dress. Splendid that at last you will have something smarter. Both of us have become rather excessively down-at-heel....

Harvested another pound of strawberries. The rose by the house is blooming splendidly — the blossoming bouquet, a good 20 roses sitting next to each other & forming a bouquet. Various flowers in the round bed are also blooming splendidly....We have also sown lettuce, radishes and spinach....The weather is wonderful, sky almost blue-black, little clouds here & there. Quite windy during the day, which is a good thing — otherwise it would be too hot. In the sun it's still like an oven, though. Moonlit nights bright as day....And now to work — woodcuts. I can't wait to get started. Apart from that I'm not doing very much. — Letters, garden, walking. And thoughts

60 Wassily Kandinsky, *Romantic Landscape,* 1911

wander away from & return to the woodcut. Much, much love.
Be healthy, strong & cheerful.

Your W.

Today it was summer. warm. We went a long way out to the rural
suburbs & looked round the college of gardening & the big new
modern school for young ladies. All very fine. Yesterday we went
to a splendid "motion-picture" show.

BERLIN,
JULY 6, 1911
GABRIELE MÜNTER TO
WASSILY KANDINSKY

I am now sitting in Mc. [Munich] and waiting for the Marcs....
It was 33° [91° F] in the sun yesterday. *All* the rooms (incl. "stu-
dio" wet patch on floor gone!) became completely warm, or
hot, & dry. In dining room it was 19°! — Yesterday we sowed
the newly bought seed (with you at Bergmann's), picked two
pounds of black currants, 1 pound strawberries, ran still higher
wire for peas, which are all in bloom & lush, sprayed bean pests
with soft soap with good results....

MUNICH,
JULY 10-11, 1911
WASSILY KANDINSKY
TO GABRIELE MÜNTER

111

Monday, just after 9 a.m. Yesterday I was interrupted by the arrival of the two Marcs with Dr. Hagelstange, museum director from Cologne....I then showed him your work & H. was *very* interested, made a careful note of the name & showed great taste & sensitivity. Best of all he liked the last big still life (from the bedroom w. easel) & the small Murnau landscape from our garden with sunflower. He *very* much liked me and Bossi in transcendental conversation, me at the tea table (with cake, at Anja's), dark still life with many madonnas. I told him you were coming to Bonn and gently hinted that you might visit him in Cologne....I am fairly sure he will arrange a collection for you: he is also on the committee of the Cologne Kunstverein. *So be sure to pay him a visit!*...Just make the most of your stay in Bonn & get to know as many people as possible! Will you perhaps do a bit of work there? Or is not possible to get in the right mood? Well, now I have to start thinking about errands. All my fondest loving wishes & have a really, really good time.

<div align="right">Your W.</div>

BERLIN,
JULY 12, 1911
GABRIELE MÜNTER TO
WASSILY KANDINSKY

Well, I spent a morning chez Mr. Köhler, he sends you his regards. Was very nice. Has some very fine things in his collection & gave me 3 fine photos. Unfortunately I was late getting there & did not have much time, as it was well into lunchtime & I was afraid they hadn't yet eaten. I'll tell you about the collection when I see you....I have been to the Kaiser Fr. Museum 2x....I am naturally delighted at what you say about Hagelstange & that he is interested in me — that would be splendid if I got a good collection & also sold things....My relationship with the Schr's [Schroeters] is somewhat superficial — but quite good all the same. Of course I feel out of place here — They are all the kind of people I always allow to put me in the shade — but that doesn't stop me from feeling it — & now too I am fully aware of it....

I will bring recipes for cakes & salads. Did you sow all the seed?...The last few days have been pretty warm here, too. It's marvelous that the house is drying out so well....With the leaf lettuce you have to cut off the older leaves to eat, then others grow in their place....Well, that seems to be all for today. Take care of yourself! Be healthy, industrious, cheerful! Your Ella. Kind regards to Fanny.

Today I shall be doing a good bit of work in the garden...& making woodcut print (jockey). So it's now 10 days without a break that we've had sunshine. Only *one* nocturnal thunderstorm the whole time. Bright moonlit nights. How sorry I am that you had to miss all this after 3 years of rain & cold! That's what I often think. Well, enough for today: work awaits me. Many, many fond greetings, my dear Ella. Do stay well & cheerful. & don't leave me completely without word. As I say, a card will do.

<div align="right">Your W.</div>

<div align="right">MURNAU,
JULY 13, 1911
WASSILY KANDINSKY
TO GABRIELE MÜNTER</div>

Thank you for Tuesday's nice letter. Did the Museum of A[rts] & C[rafts] even more thoroughly today....the last few days I have been wavering this way and that — leave on Saturday? leave on Monday?...it's unpleasant to rush — & *if* I miss one person or the other I can console myself with the thought that I am not after all particularly good at making contacts....So in the end I will have been here 4 weeks instead of 2! — but I wasted the first week through laziness & lethargy. Yesterday we had supper

<div align="right">BERLIN,
JULY 13, 1911
GABRIELE MÜNTER TO
WASSILY KANDINSKY</div>

<div align="center">61 Wassily Kandinsky, Lyrical, 1911, color woodcut</div>

in style in the garden with concert — Friedel was there for once & she liked the fountain so much she wanted to paint it.

BERLIN,
JULY 14, 1911
GABRIELE MÜNTER TO
WASSILY KANDINSKY

I won't be leaving until next week after all. I miss you, my dear. How are you, what are you thinking, what are you doing?... Lately I have been somewhere every morning. Today museum of anthropology 2 1/2 hrs....I think of you a lot & how kind you are & I rather miss you. It really grieves me that I am becoming so estranged from my circle of friends. I have the feeling that it was always this way to a certain extent — but now I see things so much more clearly. It is good and hot here too now. Yes, a pity that I have to miss the "summer" in Murnau....

I hope I can enjoy part of the fall in the country with you!

MURNAU,
JULY 15, 1911
WASSILY KANDINSKY
TO GABRIELE MÜNTER

Thank you so much for the two long letters....I am very glad your apathy has waned, or, to be more precise, that you have overcome it, so that you are developing an appropriate enthusiasm for doing things & visiting people. So be sure also to visit Dr. Hagelstange in Cologne!...Sowed leaf lettuce, which as luck would have it is now being slowly but perseveringly watered by the rain. Since the afternoon we have in fact already had 3-4 thunderstorms. It's also blowing up quite a gale. My countryman's heart rejoices: the ground was already so dry that deep wide cracks were appearing! And that in Murnau! We had to water assiduously every evening....Everything else is fine too. My time is well organized: the day for me, 2 hours (or 3-4 with mowing etc., doesn't happen very often) in the evening for the garden, which is thus in good condition....Yesterday I at last did all of 7 sketches for small (1 large) woodcuts, which were still needed for the album [i.e. *Klänge* (Sounds)]. Now I'm going to get on with the cutting again.

MURNAU,
JULY 18, 1911
WASSILY KANDINSKY
TO GABRIELE MÜNTER

I'm still chipping away, making the prints from the last set of sketches. Perhaps I shall paint soon: the Last Judgment, on the lines of the glass picture. Apart from that I don't believe I am doing much thinking. — Fanny sends her regards, she keeps meaning to send you the noodle recipe & when I write we both forget. She's in the village now. — The apricot looks as if it will bear plenty of fruit. A lot of peas hanging & ripening....Cherries tasted good: juicy, sweet. I should so like to send you some of our produce, but it would only arrive as mush! Since the main element of the parcel would be strawberries....Much,

62 Wassily Kandinsky,
Last Judgment,
1911, color
woodcut

much love — I want you to be cheerful, healthy, good-spirited. Perhaps I'll go over to the Marcs' for 1 day this week, as they have mother visiting and can only come here after 24th. So once again very much love to dearest Ella from W.

Just finished with the watering (which is now so necessary): it takes approx. 20 cans or 3/4 hour of pumping & spraying. Then we shall be busy bottling again. Everything is wickedly expensive here, though. My supper mainly consists of our own strawberries. The round bed is a pretty picture of blooms, with dandelion and goodness knows what else....And the vacationers this year! Not so nice anymore. From where we are of course I don't see many; but when you go into the village...where it was like a furnace today.

Of course you too would like to weed & harvest, poor dear Ellchen! Indeed it is a positive affront that this year is so lovely after the crazy 3 years before. Now, however, it is almost too hot. For example, the bedrooms are too hot: I sleep with just a sheet covering me. Even the guestroom is now positively warm....I am

MURNAU,
JULY 20, 1911
WASSILY KANDINSKY
TO GABRIELE MÜNTER

63 Wassily Kandinsky, *All Saints I*, 1911

now cutting the "Boat Ride," which I have transposed into the wood really well: dark violet, light red (approx. Saturn red) & a little black. The Lyric [Kandinsky's famous woodcut *Lyrical* after the painting in the Boymans-van Beuningen Museum, Amsterdam] has turned out well in wood, better than the painting.... Next week I'm going to embark on painting: "Last Judgment." How am I to hold the brush?... Anja also sends her regards. Fanny as well. And I too with all my heart, dear, splendid Ellchen. Be healthy, happy, soak up — all! — impressions.

Yr. W.

MURNAU,
JULY 22, 1911
WASSILY KANDINSKY
TO GABRIELE MÜNTER

I am so terribly sorry that you are not enjoying the wonderful weather here...& especially are getting nothing out of your perseverance, pains and toil in the garden, now that everything is flowering so beautifully and bearing all kinds of fruits. Of course you are getting something from your journey & it is good that you have gone (it will enrich you, I am sure & perhaps also

be useful (collection & that sort of thing) in a material way),
but still, when the garden gives me pleasure I am very sorry that
you can only get it in your imagination. Ah well! we'll make up
for it in the fall! Right? And prepare the flowerbeds for spring
together and make the garden a lot nicer still for the coming
year. You know how lovely the fall is here. Now it is *too* hot, if
anything. And the *dust* there is in Murnau! Isn't that extraordi-
nary? The eternally wet "Saugasse" is dusty. Everything is crying
out for rain. Now and again we are even watering the...lawn.

Münter continues on to Herford to visit her relatives, the Busses.

HERFORD,
JULY 24, 1911
GABRIELE MÜNTER TO
WASSILY KANDINSKY

It is very nice here. I have hardly seen anything of H[erford]
yet. This a.m. helped to skin gooseberries and chatted the while
with Julie....Yesterday evening we had a lovely walk to "Wald-
frieden" (1 whole hour). It was very nice, I find the landscape
appealing & could make something of it, immensely pretty & I
would like very much to show it to you some day....We had a
good time & lots of fun....Want to look round Herford — old
churches! & am supposed to be invited here and there to *Pickert*
[potato pancakes with raisins: a regional dish].

HERFORD,
JULY 25, 1911
GABRIELE MÜNTER TO
WASSILY KANDINSKY

The surroundings have a lot to offer me — a lot of motifs. Lots
of d.[ark]-brown-red houses — the landscape with the corn
reaped in some places and stacked so prettily — & hills every-
where — & the big deciduous & coniferous woods where it is so
cool & fragrant — & there are no snakes. When we can, the 2
of us should take time off, 1-2-3 months & find ourselves some-
where around here nice — cheap — empty woodland resort
(forester's house or the like) & paint & you sniff the pine-
scented air. Today again went on *lovely* excursion. Me barefoot
in the woods for hours....Just fancy — today I began to have an
elegant white dress made! isn't that a laugh? The dressmaker is
doing it *at once*. I wanted to have a *thin* blouse & I'm going to
get an elegant woolen voile!...Can you send me proofs of Lyri-
cal & Boat Ride?

 Do you notice any difference in the peas? There are 2 vari-
eties, you know. And are you picking them early enough for
cooking?

In the meantime Franz and Maria Marc had arrived from Sindels-dorf to spend a few days with Kandinsky. This was their first visit to the house in Murnau.

MURNAU,
JULY 26, 1911
WASSILY KANDINSKY,
MARIA AND
FRANZ MARC
TO GABRIELE MÜNTER

Wednesday just before 1 & hungry. — Yr. letter of 24th recd. today. Many thanks and much love. Stay well and happy.

Yr. W.

Dear Miss Münter — we are delighted to be spending a few days in your charming house in Murnau. Next time, I hope you will be here too. Thank you very much for your nice postcards and sincere good wishes from

Maria Franck Marc

It is hot, hot, hot. Greetings from the 3rd tired fly

F. Marc

MURNAU,
JULY 28, 1911
WASSILY KANDINSKY
TO GABRIELE MÜNTER

It is v. hot again today & after the 2 days of conversations, walks etc. my head is not feeling particularly brilliant....Anyway, M.[arc] says you really must go to Hagen, tell the servant you wish to speak to Dr. Meier (secretary) as a member of the NKVM. You must be nice to everybody but present a bold face & ask quite innocently (when the moment seems right) whether they would be at all interested in putting on a show of your stuff. The same procedure in Barmen, speak to Dr. Reiche etc....Be sure to make the acquaintance of Cohen and Hagelstange. (*My* opinion: concentrate on Dr. Hag.: here we all have the impression that he is *very* interested in you....) M. thinks it would be best if August Macke traveled with you. He is terribly good at tub-thumping (does it all the time) & cuts a good figure. So go and see him first, ask him what he thinks. Perhaps he will suggest accompanying you....So that's that! Now another thing. Marc is going to write to Köhler and tell him that some of your pictures will be traveling from Paris via Berlin, that among them there's a *really* excellent one (the Yellow House) & wouldn't K. perhaps like to see it....We were thinking of a price of 400.—. I would be overjoyed if something good came of this plan.... Anyway, the Marcs arrived the day before yesterday just after 9 a.m....I picked them up, we drank milk at Steiger's & then came back here. They very much liked the house. Liked your room best, I think....Fanny really stuffed us with food! She did it all very nicely and elegantly. Went to see Rambold in the morning & looked round village. Then *dinner*, followed by coffee in

64 Gabriele Münter
 in Herford, 1911

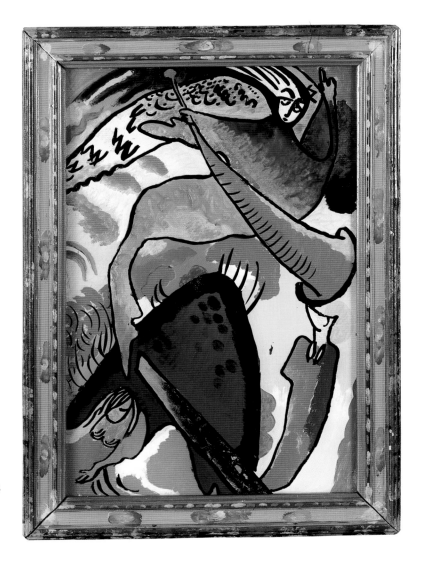

65 Wassily Kandinsky,
 *Angel of the
 Last Judgment,*
 1911, glass
 painting

the summerhouse. Afternoon Staffelsee, Seehausen (tea) & back
home about 8 for supper. Talked until 11 & then I took them
to the Angerbräu, to the room booked earlier (by Fanny). Yes-
terday 1/2 past 8 breakfast together at our place, village again,
i.e. church....5 o'clock: tea, during which poor old Hellmuth
[Macke, August Macke's cousin] suddenly appeared on his bicy-
cle sweating profusely and immediately thrown into consterna-
tion by the news that we were all leaving in 1/2 an hr. The M's
went home, with me accompanying them as far as the Rieg-
see....Under a fireball sunset I walked home from Riegsee after
a very amicable parting from M's. — I believe he has it in him

to produce another fairytale. — Marc asked to borrow my picture with rider & shafts of light to hang it at his place. Perhaps I'll make him a present of it.... I can just imagine you in Herford! And am glad & laugh & am glad again that you are inhaling that atmosphere. Oh, I know how it resonates in the soul! — Much, much love, then. Do be healthy, hard-working, of good cheer & rejoice! Yes? M's send you *best* regards. Fanny also sends hers.

<div align="right">Your W.</div>

Everywhere you go, always mention that you are from the NKVM.

HERFORD,
JULY 28, 1911
GABRIELE MÜNTER TO
WASSILY KANDINSKY

Received card with Marcs today. Thank you. I am now definitely leaving on Monday.... And at times I do so wish that you were with me & could see everything I see.... Yesterday evening we had *Pickert*! at aunt's. Fritz says — "when I lose my liking for *Pickert*, I'll be dead."...

This morning I recd. letter in which you tell me all about Marc visit! Please, how am I to approach Hagelstange? *Better* to *write* first so I find him at home? *What is his name & addr.?* Do you know if he is staying long in Cologne?

MURNAU,
JULY 29, 1911
WASSILY KANDINSKY
TO GABRIELE MÜNTER

Raspberries still coming in dribs & drabs. Strawbs. finished (except for this month's). Honeysuckle, roses by the house finished. Apricots turning yellow. Central bed almost fully in bloom. *All* pinks, too. Until later then, dear, dear Ella. Much love and fondest wishes. Have a good journey! Be careful of the heat!

<div align="right">Your W.</div>

HERFORD,
JULY 29, 1911
GABRIELE MÜNTER TO
WASSILY KANDINSKY

Yesterday must have been *the* hottest day. What have you been doing?... I think too — it might be sufficient for me — if I have Hagelstange, Reiche, Cohen on my side — & anyway I'm not so confident about approaching people. I'm sure you'll agree — I could just as well leave out Hagen [home of the Karl Ernst Osthaus-Museum, known for promoting modern art].... It's nice that Marc & Macke are so concerned & helpful! But I want to ask at least *500* from Mr. Köhler for the Yellow House. By the way, everyone is so excited that I was planning to show it in the fall in our exhibition [the NKVM show]....

You must write to me often while it is so hot. Even thought I might telegraph so I hear from you in Hagen; as I am not going there now it is not necessary — but this heat makes me a little nervous.

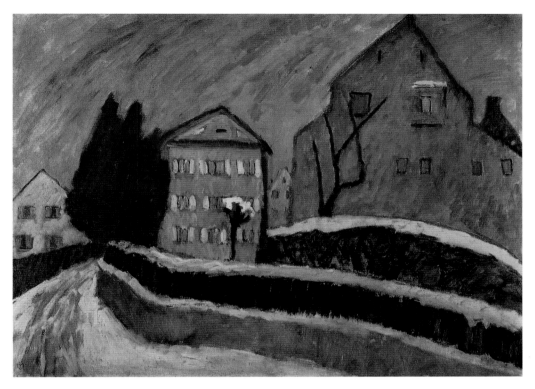

66 Gabriele Münter, *The Yellow House*, 1911

So! Worked very hard! Framed, painted, signed etc.... I think you should *definitely* visit Hagen, perhaps Barmen (forget "perhaps," which I only wrote because I feel sorry for you) & get to know the people.... Hag.[elstange] will I think be in Cologne all the time: he has already been on his trip, hasn't he? Perhaps you might also visit Miss Wor.[ringer] and the Gereon Club. You can look it all up in the directory.... *Personal* contacts are always very!! helpful. You must get to know everyone you can find. Just be natural — that's enough! Just think: it may well be quite a while before you are in the area again & by then even the best of atmospheres will have evaporated!! Don't be so lazy!... Don't miss this opportunity! Merciful heavens! How I have to keep on at you!!!!...

That you want 500 for the "Yellow House" is in order. But bear in mind that you can get French pictures of that size for 300-400, that Köhler is a collector, i.e. likes to buy cheap, that it is not important whether you get 100 more or less, but it is impor-

MUNICH,
JULY 31, 1911
WASSILY KANDINSKY
TO GABRIELE MÜNTER

121

tant that you hang in a *good* up-and-coming Berlin gallery. Anyway, we don't know if Köhler will want to see the picture: he is shy and easily put off by bold overtures....Bear in mind also that you are a woman, which has its disadvantages as well as advantages....So, all my love. Be brave, healthy, cheerful. I wish you ev-v-very success. Again, much love

Yr. W.

MUNICH,
AUGUST 1, 1911
WASSILY KANDINSKY
TO GABRIELE MÜNTER

At the end of this week I'm planning to cycle to the Marcs': there in the morning, back in the eve. Otherwise I am working. — You are perhaps already in Bonn now and celebrating....I wonder what you will have to say of the Mackes and how things will go with Hagelstange. Well — I hope. I hope you generally benefit a lot from your travels, I mean inwardly, too. A journey of this sort (especially undertaken alone) broadens the inner horizons & often makes one more tolerant. One absorbs things unconsciously & only becomes aware of it later.

Your W.

BONN,
AUGUST 3, 1911
GABRIELE MÜNTER TO
WASSILY KANDINSKY

Macke came in the evening, after I had telephoned him again. A tall, good-looking young man. Very likable. Stayed till 12 — It was very nice. Today I was at the Mackes' from 6-10. The wife is charming, interesting. And behaves quite normally, not at all affected. After talking to the Mackes I have now made my plan as follows. Will now write Hagelstange that I will call on him on Monday or Tuesday if he is at home....

[Further note enclosed:] Just wanted to say: 400 for the yellow house is all right with me. You are right. Much, much love! How are you? Haven't had anything from you yet today.

MURNAU,
AUGUST 4, 1911
WASSILY KANDINSKY
TO GABRIELE MÜNTER

Just a few words today, my dear Ella....I am totally preoccupied with the Last Judgment, it's now the second day I've been sketching it one way & then another & thinking it over. Some things very good, others I can't get right....Today I'm going to have one of our (your) radishes for supper — the first time — & our lettuce.

BONN,
AUGUST 5, 1911
GABRIELE MÜNTER TO
WASSILY KANDINSKY

Macke came to see me this morning for 1 1/2 hrs. or longer. Mü's were out & the two of us had a very nice talk....

I am glad you are working so well! Sometimes wonder if you don't miss me just a bit. I'm already looking forward to coming home....Saturday morning. today card from Hagelstange, has

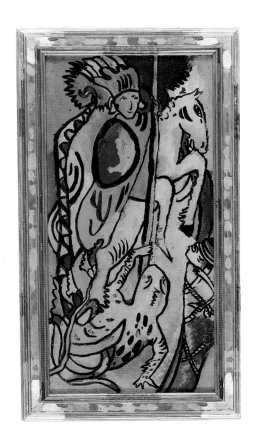

67 Wassily Kandinsky,
 St. George II,
 1911, glass painting

been away since day before yesterday! Perhaps I'll set off tomorrow anyway.... Well, doesn't matter all that much — after all, he knows my work.... If only I had a proper idea of what I should say to the other people from the art world — but I shall still probably start out tomorrow and simply look things over in passing!

Today Josef Fürst is celebrating his 20-year anniversary as president of the gymnastic club, founder of the local amateur dramatic society etc. Pomp & circumstance! Now I am painting and painting. Nothing but sketches for the Last Judgment. Not satisfied with any of them. But I must find the right way to approach it! Patience, patience.... My album is nearly finished and I want to start printing at the end of August. Fondest greetings, dear Ella, and very best wishes. Do get to know the Mackes better if you think fit.

Your W.

MURNAU,
AUGUST 6, 1911
WASSILY KANDINSKY
TO GABRIELE MÜNTER

Not much today, as I am about to ride over to the Marcs. It's a beautiful day & I'd like to get to S[indelsdorf] before it gets too hot. Received your 1st letter yesterday. Many thanks! Am very annoyed that Hagelst. is out of town! — I was just going to send you our apricots & then you write of the vast quantity you have there. So what! I'll send them anyway: perhaps they will taste different. I had to eat the ripest one yesterday — it was like butter.

In a letter hastily written in a Düsseldorf hotel, Münter told Kandinsky about her further visits to Max Gosebruch at the Folkwang Museum, Essen, the art dealer Alfred Flechtheim in Düsseldorf, and Richard Reiche of the Barmen Kunstverein. She had previously sent two cards describing her somewhat awkward encounter with Fritz Meier, a curator at the Hagen museum, after failing to make contact with its founder, Karl Ernst Osthaus. She sent another lengthy letter from Cologne soon afterwards, on August 9, in which she spoke of her mixed feelings about the various art historians. Returning to Bonn the next day, she told Kandinsky that she had "spent quite some time at the Mackes' again today."

Thank you very much indeed for the many detailed and clear reports! When I was in Sindelsdorf, Marc told me Aug. Macke was quite enchanted & positively enamored of you, he wanted to accompany you on your tour. But now you are traveling alone. Perhaps Macke didn't know that you were setting off so suddenly. It *is* a pity, as I'm sure he wouldn't let Osthaus get away so easily, & would also know how best to approach that stupid Fritz.... But you are certainly getting around!! I take my hat off to you.... 2 days ago we had the committee meeting [of the NKVM]. When Marc told me about it we laughed ourselves silly, things were falling out of our hands! Absolutely extraordinary! Tell you about it when I see you.

Got the letter from Bonn in the Cologne envelope today & thank you very, very much for all the reports.... Even if you haven't directly achieved anything on your very enterprising & courageous journey, you *have* seen a lot & several important people have seen you, which is always a good thing. So we can write off Hagelstange, I suppose? In other words, you won't be seeing him after all? I am very pleased that you get on well with the Mackes....

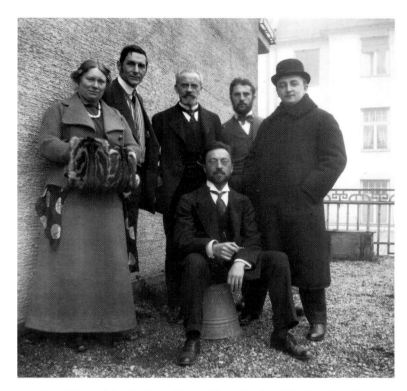

68 From left to right: Maria and Franz Marc, Bernhard Koehler, Wassily
 Kandinsky (seated), Heinrich Campendonk, and Thomas von Hartmann.
 On the terrace of No. 36 Ainmillerstrasse, probably late 1911

I have made 2 oval beds & planted everywhere 1 row of wall-
flowers & 1 row of feathered pinks. Hard work! Will it be worth
it? The hollyhocks are beginning to flower. The central bed is
full of flowers & looks very nice. We have home-grown vegeta-
bles all the time. Cucumbers flowering, very luxuriantly. The
weather is marvelous. Sunset fabulous....I can expect you in 11
days then? Be healthy, cheerful! Your W.

Wanted to tell you what else has been happening. I went to the
Wallraf-R. Museum in Cologne on Thursday — marvelous things
they have there. Bought some more photos....In the late af-
ternoon I went to Bonn. And as the Münters had gone out with
their guest I went over to the Mackes' and told him all about
my trip....Yesterday, Monday, I was at the dentist & when I got
home Macke had already been waiting for some time & sug-
gested going to Cologne in the afternoon for "5 o'clock" at the
Gereon Club. I agreed & in the afternoon the two of us went

BONN,
AUGUST 13, 1911
GABRIELE MÜNTER TO
WASSILY KANDINSKY

there — looked round the museum of arts & crafts & at 5, after telephoning, went to see Miss Worringer at the zoo.... Miss. W. appears intelligent & enterprising — seems to have quite a good brain....

Macke is, I believe, genuinely talented — I preach to him about inwardness, individuality, getting away from the "modern." He is still superficial, but I find there is always feeling in what he does.... He appears to be a pure, decent soul. The relationship seems similar to that with the Hartmanns — & then again not — I still don't know them so well, after all.... That will be fine, then — first a few days in Munich, then Murnau & Sindelsdorf & after that we'll go to Murnau & perhaps I'll paint a bit again. Sometimes see things that would normally appeal to me — but don't feel at all like painting.

Kandinsky gives a full report of a recent visit by Bernhard Koehler Jr., the son of the Berlin collector. Together with Franz Marc, he and Koehler had been to see a collection of glass paintings owned by a local brewer.

MURNAU,
AUGUST 19, 1911
WASSILY KANDINSKY
TO GABRIELE MÜNTER

Just accompanied the Marcs almost as far as Hagen [between Murnau and Sindelsdorf].... Fanny excelled herself yesterday! It was all first-class & she herself put on a superb show. All 3 (especially K.!!) [Koehler] were quite entranced & indulged

69 The music room of the "Russians' House" in Murnau, seen from a corner of the dining room, 1910

70 Fanny Dengler, the couple's housekeeper, doing a glass painting.
 Murnau, 1911

themselves to the full. The stove wasn't working, the place was
in a mess & it was not the best of times to receive visitors. But F.
conquered all the difficulties.... The visitors were astonished at
her glass paintings.... Yes, I think the "Last Judgment" will soon
be ripe within me. Went to the brewer's yesterday with Marc and
K. & today something else fell into place in my picture. He has
some fine things, too. The Marcs, Köhler, and the Rambolds
send their best regards. The first 3 very much regretted that you
had not yet returned. This is my last letter to you, darling Ella.
Have a safe & enjoyable journey & be sensible. Give the Mü's
my regards — & Macke. As from Tuesday I am sure to be in
Mnch & shall await your telegram....

And in 8 days' time we'll both be here & you can enjoy Mur-
nau & relax. You've earned it! And you can do some painting....
Well, in 3-4 days we won't need to write any more letters. Look
forward to seeing you.

 Yr. W.

TENSION AND SEPARATION:
1912-14

The development of the relationship during the last three years up to the outbreak of the First World War can only be traced here in outline, with the help of characteristic excerpts from the correspondence. Most of the letters that have been preserved were written during Kandinsky's absences in Russia, which he visited again in the fall of 1912 and summer of 1913.

In October 1912, before continuing his journey via Warsaw to Odessa, Kandinsky stopped over in Berlin, where he met Herwarth Walden, who was preparing the artist's first one-man exhibition for his Sturm gallery. Kandinsky also sounded him out on the possibility of arranging an exhibition for Münter; a postcard dated October 6, 1912, reports: "Discussed many things. W[alden] to visit you beginning of November. Accepted your collection in principle."

Münter was meanwhile sorting out her (and Kandinsky's) entries for a group exhibition of works by their artist friends, held in Munich at Hans Goltz's Neue Kunst gallery. On October 7, 1912, she gives a detailed report on the attitude of the dealer Goltz, and the behavior of a prospective buyer and speaker at the opening, the Austrian journalist and writer Joseph Lux. In résumé she comments: "So far I have been doing various same old things, am always busy and generally mooch around."

On the evening of his arrival in Odessa, Kandinsky reports at length on the members of his family.

Father looks excellent. Mother thin, but in relatively good spirits. Her husband [Kandinsky's stepfather] has trouble walking, but otherwise makes a good impression. In the train I did a lot of resting, reading, and thinking about art, of course.... As I said, W[alden] will be glad to take your collection. I get the impression he has a certain feeling — unprompted — for your work.

ODESSA,
OCTOBER 9, 1912
WASSILY KANDINSKY
TO GABRIELE MÜNTER

Now I suppose you are still sitting up with your parents? Or maybe you have all gone to bed by now. I cannot properly set my mind at rest — I am sorry that I didn't insist on a telegram — I would have it by now. The last few days I have been restless

MUNICH,
OCTOBER 8, 1912
GABRIELE MÜNTER TO
WASSILY KANDINSKY

◁ Detail from fig. 72

129

and incapable of anything — was always intending to work — couldn't find the time firstly, & secondly, when time, no energy. Things are gradually beginning to improve, though. Now I have been sitting for quite a while & dozing — can't get around to doing anything & so I thought must write you a few more lines. This morning, instead of painting, searched my studio for mouse I saw yesterday. Didn't find it. But the energy was gone. Afternoon tea at 5 — just after 7 Stadler arrived. Listened to the story with interest & indignation [here, Münter refers to the problems with Joseph Lux, which she discusses in more detail in subsequent letters]: He said I was a good storyteller! bah!... I hope soon to find a better use for my time than thinking about what I ought to be doing....I was glad to hear about the card from Walden — you had a good effect on him — how intelligent & sensitive is he?

Two days later, Münter writes at length on the opening of the exhibition at Hans Goltz's gallery.

MUNICH,
OCTOBER 10, 1912
GABRIELE MÜNTER TO
WASSILY KANDINSKY

The great moment has been and gone!...I shook hands with Messrs. Erbslöh, Kanoldt & Bechtejev. Piper & Dr. Fischer didn't come close enough to make a greeting necessary. But the aforementioned 3 gentlemen came up specially to shake my hand. Miss K[anoldt] also made a point of greeting me particularly

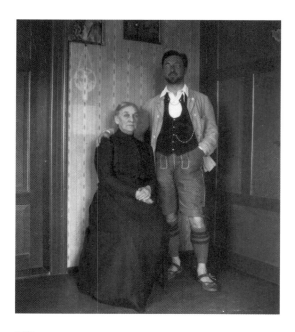

71 Kandinsky
 and his mother.
 Murnau, 1913

72 Gabriele Münter, *Open-Air Café*, ca. 1912

nicely. She is always complaining about her poor mother's health....

In the end I went home with Klee & the Stadlers after being invited to supper by the Goltzes. One has to have a second party & eat up the leftover cakes....Still can't find the energy to paint. I no longer have a clear-enough recollection of the spring sketches from Murn. Will have to gather new material. Lazing around is still what I most feel like doing. How are things there with the [Russo-Turkish] war? Please give me price list for your collection, or tell me where I can find it here. And answer q. whether I must send the BR [*Blue Rider* almanac] to the museum director here.

I am fine & I feel very comfortable with my family. Whole days together & no strain at all. My little nieces ask nothing of me, they insist on sitting next to me, but play by themselves or tell stories etc. Everything is idyllic in the best sense of the word & I don't think about anything....Please ask Piper to send me 5-6 leaflets by second class mail. And when "Sounds" is ready [Kandinsky's *Klänge*, a book of prose poems and woodcuts published by Reinhard Piper], 4 copies by *registered* mail. If he would be so kind!

ODESSA,
OCTOBER 11, 1912
WASSILY KANDINSKY
TO GABRIELE MÜNTER

Kandinsky replies to Münter's letter of October 10. The reference to the "Lux purchase" concerns a major picture, Improvisation 9, which Kandinsky had sent to Joseph Lux on approval. Lux, evidently something of a rogue, had refused to return the work for the Goltz exhibition.

ODESSA,
OCTOBER 14, 1912
WASSILY KANDINSKY
TO GABRIELE MÜNTER

I am delighted that Dr. Stadl[er] is so nice to you & that you get on with him so well. To me, the Lux "purchase" now seems very far away and no longer disturbs me in the slightest. We'll let him sit on the picture. We did in fact make a *sort* of agreement about not exhibiting it....After dinner at mother's today I read some humorous stories & we all had a good laugh. Mr. Kosch. [Kandinsky's stepfather] has become incredibly nice and agreeable. He laughed until he cried. I also told them a lot about my life in Munich. My heart feels good & warm here and is resting from all the wear and tear. My only worry is that I will get too fat. I'm just lazing around. Although there are so many distressing things happening on the political front. I try not to let it affect me. You know about the war anyway....You will paint (seriously) in due course? Won't you? In that & in everything I wish you *much* strength and joy.

The Lux business had meanwhile been preying on Münter's mind, and she had sent the renegade collector a letter couched in very plain terms; Lux had evidently replied in equally blunt vein. For Kandinsky's information she encloses a copy of her letter to Lux, which Dr. Alfred Mayer, a mutual friend, had helped her to write.

MUNICH,
OCTOBER 14, 1912
GABRIELE MÜNTER TO
WASSILY KANDINSKY

Today I fear I can again give you no joy with my letter. Here is the reply from Mr. Lux....Luxy-boy can certainly show his teeth & he isn't even trying to deny it all. Don't you think the time has come for you to step in and confirm what I wrote as true?...

I hope you are not too cross with me, but I don't think you will be surprised at the turn things have taken....How are you?...Do you forget me a lot when you are far away? Just like when you are near? Will you help me now? Perhaps you could telegraph me to say whether you are going to help me....Don't be cross, will you?

Kandinsky's reply manifests mild but unmistakable disapproval of Münter's actions in connection with Lux, but he also talks at some length about what he has been thinking and doing in Russia, and signs off on a conciliatory note, reassuring Münter that he bears her no ill will.

I see! you are continually looking for new people to back you up in the Lux affair. The poor major also had to rack his brains. Stout fellow! The letter is well-written (here & there a little too "spirited") & I am very sorry for you, as you still let it upset you & waste time & indeed energy. I should very much like to do you the favor of saying "yes." But I can't. I told my mother the story. She was also indignant & said the following: I shouldn't have let the picture out of my hands, but now it's too late to take the matter up again & not good form: what's done is done. So the same view as Anja.

ODESSA,
OCTOBER 18, 1912
WASSILY KANDINSKY
TO GABRIELE MÜNTER

73 Gabriele Münter, *Kandinsky and Erma Bossi, After Dinner,* 1912

The next day, however, Kandinsky's vexation knows no bounds.

ODESSA,
OCTOBER 19, 1912
WASSILY KANDINSKY
TO GABRIELE MÜNTER

Now I may say: one in the eye for you. Joking aside — I find the whole business very embarrassing. Lux is right insofar as it is my & his affair & it's my responsibility — if anyone's — to say something....A fine kettle of fish! I expressly asked you not to write. On the face of it, Lux is perfectly justified in misinterpreting the motives for your action....You have put me in a thoroughly bad mood. That is, because of you I am *very* embarrassed. The business doesn't trouble me personally at all. You have acted without my authorization and you must now bear the consequences alone. I told you clearly that I was not going to get involved in such matters. And *I cannot do so*. I find it repugnant.... What did you really expect him to do? Hand back the picture, full of remorse? Or cast it at my feet? He has acted logically and according to his character. But a correspondence of this kind is not in keeping with *my* character and I too must be logical. Lux's letter is base from beginning to end. But you prompted him to write it....Why did you take that course of action? For the sake of justice? That is not the way to achieve it. In my interest? Well, it would be in my interest to make things easy for me & not get me all upset because of you. I was feeling so good & today I have been running around 1/2 the time "with a thorn in my heart"....How often & explicitly I asked you to forget about the letter!...Why did you do it? I very much wish you could see the whole affair in a cold light, from an elevated point of view.

Best wishes Your W

The next morning Kandinsky adds a postscript, taking some of the sting out of his harsh words.

Poor Ella, I feel very sorry for you. But I really cannot get involved....What a drain it all is on strength, nerves etc! Please, please, let that now be an end of this dreadful affair.

Münter replies to his accusations and is initially at pains to defend her actions, insisting that — though she had indeed known that he did not want her to do anything — he had not exacted any promises from her. At the end of the letter, in which she drafts a short reply to Lux, she adopts a somewhat meeker tone.

You reprimand me — you are right — I am right. Each of us did it his own way. You know what I am like, don't you now — if it was really so important for you, didn't you know or think that you could have counted on me if you had made me promise? You only kept saying — please, don't do it — it will do no good & I kept saying — I can't guarantee anything — I'm not going to leave it at that. If you had forbidden me more forcefully or if you had got me to promise, I wouldn't have listened to Mayer's suggestion — that I should write — and immediately thrown all my resignation overboard. So — in this case you are by no means in the right — you want to live for yourself & wrapped up in yourself & don't give a thought to my needs. It would be easier for you to adapt yourself to me than vice versa — or if you were to make a few concessions it would be easier for me to live according to your manner & tastes. Am I right?... So if you did say I definitely had no authority to write, I have forgotten about it. You obviously didn't say it in a way that would stick. Even now I can't remember hearing these words from you — I only know that you said you wouldn't like me to....

Well if you don't want to [write to Lux], that's all right. Lux can carry on luxing.... Hope you're not angry with me anymore. Am I to keep things from you then? Just don't take it so seriously! As far as I am concerned the affair is more or less settled. You needn't think I went on about it to Stadler as well. I find it all too boring for that.

MUNICH,
OCTOBER 22, 1912
GABRIELE MÜNTER TO
WASSILY KANDINSKY

Kandinsky tells Münter at length of his fears regarding the course the Russo-Turkish War is taking, but the dust has still not settled on the Lux "affair."

I'm a bit scared about your advertised letter with new excesses. Is it Lux again? "Do you return to haunt me again?" It makes me shiver!...Don't even *think* any more about this idiotic business. *It is not worth it.* Is it not so? Has Lulu [Jawlensky] told you about the liver medicine? The Giselas [Jawlensky and Werefkin] are in Munich already. Please give Fanny my regards. & once again much love.

ODESSA,
OCTOBER 26, 1912
WASSILY KANDINSKY
TO GABRIELE MÜNTER

Your W

135

Among other news, Münter reports on Herwarth Walden's visit to her studio, which had resulted in a commitment to show some of her work in Berlin.

MUNICH,
OCTOBER 28, 1912
GABRIELE MÜNTER TO
WASSILY KANDINSKY

Stadler was here to see my stuff on Saturday afternoon — we argued a bit — he doesn't look at things properly — unfortunately we were interrupted by Mrs. Marc. She was very nice. ...The Marcs came to dinner in the evening with Walden. That is, Walden was here quite a while in the morning. They were all very nice in the evening, too....Sunday afternoon W. was here again for some time & I showed him a lot of pictures. He is very nice & I like him well — he is just a *bit* too charming — perhaps he thinks he has to be with me. He praised my work highly and — at least to some degree — sincerely....He said he's never seen such perfect yellow as in my pictures. And, furthermore, he sees my personality as this warm yellow....It *is to be shown at the Sturm gallery in January* & he is sending it on tour & acts frightfully keen. It looks as if he has taken somewhat of a liking to me....

On Saturday eve. I told all 3 the Lux story as briefly as possible. W. didn't say anything & only asked afterwards if there was anything he could do — I turned it all down....Meant to say — the story seemed to make no impression at all on Marc. He said you had been uncommonly patient — but the next moment was talking about his deer....

So I'm going to let Walden represent me. Goltz is really not so interested & then with his moods it's not very nice. Let him groan about *you*, that you make things awkward for him! It was perhaps a mistake after all for you to talk to him about Marc. Now he's talking to Marc about you. Also the faces he made when I asked what he thought of the Mü idea [Münter's brother, Carl, being short of money, was thinking of trying his hand as an art dealer and wanted to learn the ropes in Goltz's gallery]. I didn't like that very much & what he said — he wouldn't come clean with me....

If you don't have any time, you can't write any letters — never mind. But tell me everything later, won't you? And spare a thought for me now and then!

Fondest greetings and best wishes

Your Ella

74 Gabriele Münter, *After Tea I*, 1912

Kandinsky's next letter shows that his anger toward Münter has abated. He responds to her news about "outrageous" bills from the NKVM, Marc's criticism of his Rückblicke *(Reminiscences), and what Münter calls "dubious" behavior on the part of Goltz, the gallery owner.*

I feel fine here and am getting lazier every day. I am not at all angry with you about Lux. You are right, too: I should have told you much more forcefully. But I always felt sorry for you because you got so upset....Do please pay the dear NKVM. Why should one dirty one's hands squabbling with such a bunch? I've already forgotten what it's all about. However, my impression is that they have no right to ask....Marc is quite entitled to criticize me. But it suits me fine that people should find some biographical nonsense in the catalogue instead of an "explanation": "Does *he* have a high opinion of himself!" they are bound to say. And as I don't, I am glad.

ODESSA,
OCTOBER 29, 1912
WASSILY KANDINSKY
TO GABRIELE MÜNTER

137

I am delighted that Walden is taking such a keen & lively interest in your art and that the collection has all been settled, and the tour. It's absolutely splendid....Marc has told me nothing of what Goltz is saying about me. I knew that my pictures would hurt his sales & told him often enough. Still, I don't really believe that he has said positively nasty things. So I am not going to get his premises? I know nothing of this. You know that things like this don't really upset me. You too should take such things calmly, or more calmly: it means very little....More and more I feel how unimportant it all is. And if it's unimportant it's best not to get upset. And in this case particularly one should remember that neither of the Marcs likes Goltz — so things look worse than they are....I am looking forward to Moscow. But to leave here won't be easy. God knows when I shall see my family again. I still feel just as good here, if not better than in the beginning. And mother & her husband are going to feel very lonely....Father is going back to his little town. But it will not be easy for him to part from me. When we were all younger it was easier. Now the heart truly aches....I am very glad that you are well & that you don't have much time to feel bored.

Münter takes back — not for the first time — some of the things she had told Kandinsky about real or imagined cloudings of relations with friends or colleagues. She also reports on the hanging of what she calls the "Futurist" collection at the Thannhauser gallery and her impressions of the exhibition.

G'day dear! How are you? On Tuesday I sent you 15 [in her numbered sequence of correspondence] — a card. Because I was afraid what Goltz said about you might not have sounded too good. You might take it to heart. I think after all he is not such a bad sort. The Marcs cannot stand him & are therefore liable to put & see things in the wrong light — we know that. We — the Marcs, Walden, Klee & I — visited Giselas [Jawlensky and Werefkin] on Wednesday afternoon....Afterwards W. suggested I go with him to Thannh. to see things by daylight — they all came along. I soon took my leave. The things didn't look so good the second time around, the enthusiasm had probably turned our heads. Anyway, on Tuesday I went to see the pictures hung. Klee, Marcs, Giselas were there — thrilled!... Mrs. Klee also came to Th., her husband fetched her & even. they *all* went to the Capet Quartet — I was going to go along,

too — but when they turned the lights on at Thannh. I said goodbye & was glad to have a quiet evening.... Epstein has just been. I had a bad night because of a cold. He says I should stay in bed tomorrow at least. I can get up for meals. Nothing prescribed. Hot drinks.

Mü [Münter's brother Carl] will not be staying here much longer. I find Goltz's behavior quite incomprehensible. Practically refused to discuss things & simply doesn't want to have Mü.... G. had told him, in writing, that he would take him on as a trainee — & now he acts like this! And I am *sure* Mü hasn't been at all tactless. He behaves very nicely. Looks good — dressed in tip-top style. G. should at least have said beforehand, "I am no longer interested — do not come." However, Mü had told him he was coming to Mnch. in any case....

MUNICH,
NOVEMBER 6, 1912
GABRIELE MÜNTER TO
WASSILY KANDINSKY

 The Schönberg concert I found disappointing.... Marcs, Klees, Mayer, Stadler.... I went home, the others drinking.... Don't let Goltz squeeze any more out of you. Really does seem to be a petty-minded little tradesman.

Kandinsky had meanwhile traveled on to Moscow. He counsels Münter against becoming too upset about Goltz's sudden volte-face with regard to her brother.

Just arrived in fine style.... Got the letter here — many thanks. Unpleasant business with Goltz — in every respect. But I'm not going to take all these doubts about G. etc. at face value. Let's see how things go, first. It seems he has something in his head that we don't understand. If it's something not very nice — so much the worse! But we mustn't be over-hasty in passing final judgment! I am very glad that you are now fully recovered. Just be *very* careful, especially at first.

MOSCOW,
NOVEMBER 11, 1912
WASSILY KANDINSKY
TO GABRIELE MÜNTER

 Much love! Regards to all, Anja & Fanny.

<div align="right">Your W.</div>

Kandinsky tells of his plans to sell his house in Moscow and build a new one on another site.

I have a splendid place to stay. 2 windows, through which I can see a large snow-covered garden, giant ravens strolling around — real Moscowish. At the end of the garden a real Mosc. old house — yellow with 4 thick columns. Quiet & peaceful, like in Murnau....But there's something else I shall definitely do: sell my house & have a big new one built. Tomorrow I'm going to see Hartmann's architect — Chelishev — and talk to him. I have already let 3 apartments in this house: the Abrikosovs (2: senior & junior) & one to Mrs. Chimiakin [Anja's mother]. Tomorrow I'll discuss the financial side seriously & in detail.

We have no letters from Münter for the period between November 6 and 26; however, from her numbering and from Kandinsky's replies we know that she must have written several times, informing him of — among other things — problems with the publisher Piper and the dealer Goltz.

Thank you so much for worrying your dear head & for your news, dear Ella. The news is of course not pleasant (what does that stupid director want?), but it is indeed much better for me to know how things stand....The new house is to cost 200 th. R. and my income will be easily double....This time I am taking Moscow more calmly (I have not gone wild), but I'm still soaking it in &...almost continuously vibrating. I feel very much at home here & I have an unlimited affinity for the contrasts. But I am longing to work...to paint & want to have complete peace for that....Keep well, cheerful & above all don't get upset about things that are not so important. Much love. your W.

In subsequent letters Münter must have complained about the "superficiality" of Kandinsky's replies, a criticism she had also leveled at his detail-packed letters from Moscow in 1910. She had more than once accused him of not reacting to what she said. The reader will find this hard to understand, since Kandinsky does as a rule respond directly to her reports and questions, while Münter appears to show little interest in his activities in Russia. Kandinsky replies to her accusations.

Your last 2 letters (i.e. one card 1 letter) hurt me. I am awfully sorry that you misunderstand me, dear Ella. You feel insulted or

"ill-treated" in cases & at times when there should be no trace of such feelings within you. You say "commercial correspondence" and are utterly wrong. You really ought to know how dearly I wish to see you content, to feel that your spirit is warm....Please cast these doubts out of your mind & do not think I am a table or think of you as a chair. If I say little of myself & only talk about "business" matters, it is only because I want you to know about my outward life. The inner life remains unchanged: in Odessa I felt how my family was close to me, here in Moscow I am soaking up the city, have the same intense feelings inside, am dogged by the same torments and doubts & attempt to achieve as many important things as I can. My mission was — as far as humanly possible — to sow the seed of freedom among the artists here & to strengthen the bond between Russia & Germany. As regards my personal tasks, I want to get the house business organized as far as possible. As regards my heart, I want to experience the city, to enjoy the company of the people I love. Every hour is accounted for & yet there are still many things & many people I have not seen. Even the Kremlin only from a distance!...And don't be angry that I didn't mention your woodcut (*if* I didn't). That was during the last few days in Odessa, I think. But I liked it almost without a single reservation & got a lot of pleasure from it. Have you cut any others? You said you intended to and had begun....So good night, sleep well & wake up sensible, cheerful, carefree and at peace with the world! All right? Much, much love.

Your W

Dear Ella, thank you very much for letter 27 (received yesterday) & those that were on your list....The woodcuts, too, which I like very much, especially the first one (lady, dogs) & the wagons loaded with earth. Have you already sent the blocks to Walden? I assume that the woodcuts will be published when you have your exhibition in Berlin? That business with Schmidt [the art historian Paul Ferdinand Schmidt] is annoying! I mean, I'm dreadfully sorry that the question is complicated & you cannot simply exhibit it....Much love & best wishes. No, I haven't had any amorous escapades. It's just that I am very sad at times.

Your W

& lacking in concentration, too — abominably!

MOSCOW,
NOVEMBER 25, 1912
WASSILY KANDINSKY
TO GABRIELE MÜNTER

Now that the Lux "affair" has been put on one side, Münter ad-dresses herself to the real or apparent problems with Hans Goltz.

MUNICH,
NOVEMBER 26, 1912
GABRIELE MÜNTER TO
WASSILY KANDINSKY

Nothing but racking one's brains & tearing up notepaper the whole morning. Wondering: *shall* I write to Goltz & offer to meet him to talk things over *or not* — & how, & what to write. But now, when it's clear that G. is bereft of all idealism & isn't bothered about *anyone* & especially not about us & our relation-ship with him, I think — it is not the thing to do & as he himself is not seeking a discussion, I cannot offer him one. I already went to the box with one letter — but didn't mail it, as I had my doubts & later I wrote 3 or 4 times more & tore the letters up again — I am afraid it will only be misunderstood if I stretch out a hand & as the man is insincere I can't do anything about it.…Anja even told me you said you thought Goltz was in the business for idealistic reasons!! I have never been so stupid — anyway, such a supposition totally contradicts G's own words.… Well it's a fact, the whole morning & now the afternoon has been frittered away with thinking what to do & how I should make it clear to the man so he understands what is right and proper — but — came to the conclusion that scoundrels have no understanding of right and wrong & one shouldn't give a

75 Kandinsky standing in front of his painting *Simple Pleasures*, 1913

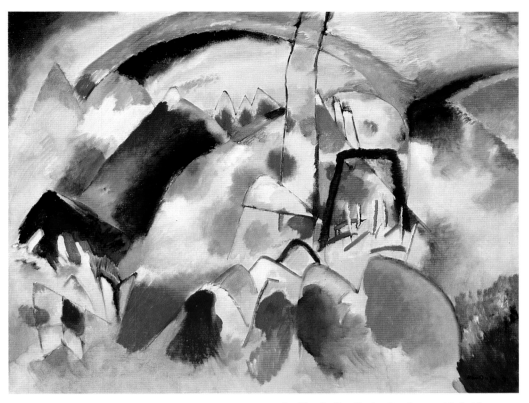

76 Wassily Kandinsky, *Landscape with Red Spot*, 1913

damn. And you too will just have to get used to the idea. — That
we always have to be overestimating people & then getting our
fingers burned! That oh-so-friendly act that Mrs. Goltz puts on!
And what's behind it?...Just be careful with the border situa-
tion. Or are you not particularly eager to come back? I feel
lonely without you & am uneasy about you — & know that with
you I feel just as lonely....

Anyway, what I wanted to say is — it appears as if G[oltz] has
something against me. Now — you know how self-critical I am &
I can assure you that I have done nothing wrong & nothing that
any moderately reasonable person can take offense at. However,
as most people are not moderately reasonable — but stupid &
conceited — they can take offense at anything. So one is on
unfamiliar ground. At any rate, Mr. G.'s manner struck me as
false back then before the opening of N.K. [the Galerie Neue
Kunst]....The Marcs had the keener nose. If I hadn't told G. I

couldn't give him any more pictures [because she had signed them over to Herwarth Walden] he would be different. Well — enough of that. I'm afraid I don't have anything better to tell you. And all of this affects you, too — you have to know. I wish I could wash my hands of all this business. Much love to you

your Ella.

MOSCOW,
NOVEMBER 27, 1912
WASSILY KANDINSKY
TO GABRIELE MÜNTER

Thanks to the uncertain political situation (poss. of war) my house business has to be postponed....So I can *not* travel when I like, as you think. But I very much hope to be able to leave two weeks from today. I really am very tired of new experiences & long for the peace of home. And I do hope it will *be* peaceful. — Just sell your stuff where you can. And don't think of charging fancy prices....Yesterday I was at the opening of the local "Secession"....I really like Lentulov & his wife best, i.e., human beings. And D. Burliuk, too, whom I estimate very highly indeed as an artist. He, Larionov, & Goncharova send you their kindest regards. Those two have a lot of fine stuff & are lively minds.

MOSCOW,
NOVEMBER 29, 1912
WASSILY KANDINSKY
TO GABRIELE MÜNTER

30 arrived today. Thank you very much. Of course I don't find all this news boring & I must know everything that's been going on. I hope you didn't write to G....Of course I never thought that G. founded the N.K. to serve an Ideal Purpose. I only took him to be very honest and not hostile to ideal purposes (inasmuch as they more or less look after themselves). It is quite possible that his new frame of mind was partly induced by Marc's behavior & the influence of the NKVM. But it makes no difference at all where it came from & how it looks today....As for me, I am keeping a cool head: these things are mere trifles. One should not waste much time & energy on them....That doesn't mean I want to turn my back on human society altogether. I would rather have new deceits and disappointments than coldness & distrust all the time....Shchukin [the Russian collector] is not buying anything from me. — Such ideas are still very foreign to him. Only a big success in Paris could make him change his mind, I think. But how is one to bring that about? And when all is said and done, that makes no difference either. I am very sorry that I am even capable of *thinking* about such things.

Münter again brings up a critical remark by Goltz about Kandinsky that she had mentioned weeks before, and warns him about letting his Berlin exhibition go to Goltz, who is negotiating to this end with Herwarth Walden. This is her last extant letter to Kandinsky from the year 1912.

MUNICH,
NOVEMBER 29, 1912
GABRIELE MÜNTER TO
WASSILY KANDINSKY

We are all leaving Goltz, he [Franz Marc] says, but *he is doing nothing & waiting for you.* — he says — not to worry, he & Walden would find a good home for your collection here. Anyway, G. said to him: (*some time ago* — I don't know if you received the letter from Marc in which he told you about it) Kandinsky was the millstone round his neck — then another time, that you could forget Münter's art, nobody likes it — and just recently, that he was finished with Miss Münter after she said "it [his gallery] was nothing more than a shop." — Well, my conscience is clear as regards G.... So he is obviously looking for a way to fall out with us.

And I presume I can hope that you are also finished with him & at any rate won't give him your coll....

I'm worried that G. might be dastardly enough to use your comments about our dissatisfaction with Marc when M. intercedes on our behalf. He may try it — but that won't bother M. — I think he'll understand & anyway it doesn't matter, as you already said the same to his face.... I do wish you could be more cheerful, I do wish you would try harder to come to terms with life — with the moment! And also to be like you once were toward me.

Much love! Your Ella

I just remembered: Marc also went to see Piper — with him, too, we seem to be running against a wall. Take things easy! And don't keep tearing yourself into shreds for other people.

Kandinsky accepts that Münter is justified in opposing the transfer of his Berlin exhibition to Hans Goltz's gallery.

MOSCOW,
DECEMBER 2, 1912
WASSILY KANDINSKY
TO GABRIELE MÜNTER

Many thanks for 32, dear Ella. I fully believe that it is not "hatred" of G. but firm conviction that compels you to speak out against showing my coll. at G.'s [gallery].... Of course I can wait a while with the Munich collection. No need to rush things, anyway! It only takes a few words to put an end to it. I chiefly feel sorry for you that we are losing another source of support.

In several subsequent postcards Kandinsky begs Münter to spare her nerves and energy, and not do anything hasty. On December 4, he writes:

Totally agree with your stance on G. I really must investigate the situation myself. *A week later he adds*: Many thanks for 35! Relations with other people are a heavy and often loathsome burden. One needs a great deal of courage not to run away, and return to one's refuge in the "tower." But I am taking everything calmly. *In the end, Kandinsky writes to Goltz himself to clear up the misunderstandings and settle the financial matters.*

For 1912, this is the last extant letter from Kandinsky to Münter; in mid-December he traveled back from Moscow to Munich via Berlin.

MOSCOW,
DECEMBER 8, 1912
WASSILY KANDINSKY
TO GABRIELE MÜNTER

I understand your reasons very well & you are right. But you must remember that there is always right on both sides. So on mine, too.... What I want is for each to act on his own account & not coerce the other. The "parties" concerned have good qualities, but in some cases more bad ones. Those who have got over the infighting should free themselves from it. We are already moving in that direction & I hope we will not remain like bottled preserves, but continue to evolve until our dying day.... No, I am tired of these affairs & want to live like a human being. Yet I feel that other people have a right to live, too. It is very good that you tell me everything & get angry. One must *hear* everything, but act...according to one's own heart.... That is the way to find peace.

I must rush off to dinner, and send you all my fondest regards. Be good, "liberal," wise & kind. Right! and healthy & well-disposed.

Your W

The correspondence was resumed in July 1913, when Kandinsky again traveled to Russia, stopping over in Berlin to see Herwarth Walden. Münter had not yet finalized her plans for the summer; about a week later she went to Berlin, and then on to Herford and Bonn to visit relatives. Though only five letters and cards from Gabriele Münter have survived from this period, Kandinsky's 27 missives indicate that there was a regular correspondence. Many of Kandinsky's letters go into detail about the planning and financing of

his new house in Moscow, and the preparations for a major exhibition — the Erster Deutscher Herbstsalon (First German Autumn Salon) — at Walden's gallery. He also talks about the planned translation into English and Russian of his essay Über das Geistige in der Kunst *(On the Spiritual in Art), in connection with which he asks Münter to arrange photos and run various errands. Other subjects mentioned include her transcription of one of his manuscripts, which has to be ready for the Autumn Salon, and new sales of pictures to the Dutch collector Beffie. The tone of the correspondence is more businesslike than in the preceding years, and there are longer intervals between the letters.*

D.[ear] E.[lla], already seen and done lots of things. Didn't find time for the card until now — about 6 p.m. Am with W[alden] in his office. Already discussed everything & also talked about my style [Münter had told him that Walden had criticized his written German]. W's criticisms are not so bad. He is going to organize your exhibition in Barmen & is confident that it will be a success.

My dear, I thank you very much for all the nice cards. I was very pleased with the first one from [the] Sturm office, which arrived yesterday afternoon — & with all the others. I kept wanting to

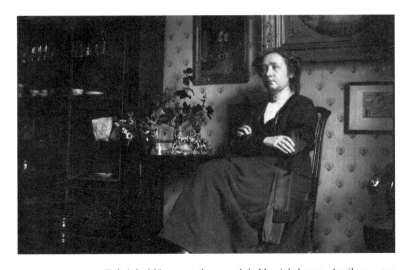

77 Gabriele Münter at the couple's Munich home, April 12, 1913

write to you as well, but didn't have the energy & kept putting it off — but have still been thinking of you quite a bit & wanted to write. Now, a proper report....

At Anja's Sunday lunchtime. then she walked home with me, as I preferred to go home — I didn't feel well....She started on again today — just like the last time you were away — about how we ought to get married as quickly as possible....I have always thought perhaps you really do have good reasons for not wanting to marry — & if you were to tell me them I would perhaps agree, as always. But now, on the other hand, it seems to me that...it's just a formality dictated by the life we lead & even if it is a nuisance, it is right after all — since we happen to live in such circumstances & among such people — that we go along — if belatedly — with the convention. A. Mayer was here on Sunday at 6 & I snapped my fingers at him from the window. He retreated in discomfiture. I slept poorly that night but felt relatively well on Monday, so I was able to receive Stadler with Dr. Dery & wife in the morning....

So what does W. say about *why* he doesn't announce your books, if his criticisms are not so bad?

MOSCOW,
JULY 10, 1913
WASSILY KANDINSKY
TO GABRIELE MÜNTER

So yesterday I was at "Wass." [Wassilievskoye, the estate of Anja's sister and brother-in-law Abrikosov near Moscow] until 9 o'clock in the evening. It was lovely. Abrik. is enlarging his park, has created an entire lake, out of a very small river. We talked a lot about the past, walked a lot, ate a lot....He [Kandinsky's father] certainly looks older: even slower in walking & movements, his eyes weaker, but otherwise in good heart & very, very nice. I took him to the hotel, had lunch with him later & am now at home for a short while....The official formalities relating to my purchase (the plot) are supposed to be starting on Wednesday, but they could take 2 or 3 weeks!...In this part of town, too, sites are becoming harder to find & more expensive. And mine is good. There is an old gray wooden house standing on it now (twice as big as our house in Murnau) and a shady garden with old beech trees as well. In the garden there's another building (tool shed). One tree is to be saved. The others will fall victim to my greed. — Much love. Be healthy & happy. Best regards to Fanny

Your W.

What are you doing? Are you going away? Or are you busy in any case?

Well, just a business letter today. I didn't ask why Walden was keeping quiet about my books. When speaking to me, he seemed to couch his opinions in milder terms. I considered it impolitic (or unsubtle, if you like) to force a "recommendation" out of him. You could perhaps touch on the question when you see him in Berlin. And besides, I don't consider the matter important....Am I to write to *Berlin* now? Much love & many thanks for the detailed letters. Have a good and pleasant journey & plenty of splendid & profitable success.

<div align="right">Your W.</div>

<div align="right">

JULY 17, 1913
WASSILY KANDINSKY
TO GABRIELE MÜNTER

</div>

Time passes incredibly quickly here. I'm not doing much, really. And still — night falls before the day has even begun. Out in the country it's like in Murnau: when I'm not outside, in the open air, I want to get out. Abrik. himself is always ready to walk around with me in the park, in the fields & woods. The others often go for walks too.

<div align="right">

MOSCOW,
JULY 24, 1913
WASSILY KANDINSKY
TO GABRIELE MÜNTER

</div>

Münter is now staying with her relatives, the Busse family, in Herford. She reports on various activities connected with her vacation and informs Kandinsky that she is still busy with his manuscript.

Wanted to paint Miss Busse after tea today but am not doing so, as too tired. Since I've been here I've had one session working on your manuscript. One evening we were invited to Tanke's for *Pickert* — during the day we (Miss Busse & I) were in Lemgo, an old town that in its way is quite as picturesque as Hildesheim & Rothenburg. Bought lots of cards & took photos. Unfortunately the sun only shone for odd moments — which I always just missed....Also drew streets & would like to paint some of them.... Today, since I don't feel like the effort of painting, I'm going to carry on with the transcription [of Kandinsky's text].... It's been raining the whole day & I only wanted to sleep — now the evening sun is starting to come out & I shall wake myself up with a walk.

<div align="right">

HERFORD,
AUGUST 9, 1913
GABRIELE MÜNTER TO
WASSILY KANDINSKY

</div>

By this point, Münter has traveled on to Bonn to stay with her brother and his wife.

<div align="center">149</div>

The Hartmanns are here & tomorrow he has his concert. Rehearsal was yesterday. Very interesting & he was splendid! His manner shrewd, courteous & confident. Both are well. I find her voice has a more inward quality again. They send you their very best regards & he says you are to *work every day*, whether you feel like it or not. That's the only way, he says, that the inner development can come about as well. . . . Today I feel tired & nervous & long for peace and. . . work. Much love, dear Ella. Be cheerful, healthy, industrious.

Your W

Kandinsky has informed Münter that he will be going to Petersburg for about two days at the end of the month and will then be traveling to Munich via Berlin between September 3 and 5.

I am sad that you never feel the need to let me share in your experiences there by giving me detailed news. It is not a good sign, nor is it a good sign that you are prolonging your stay as well.

I am trying to spend every available minute working on your manuscript — it is very long — but I don't know whether I can take the responsibility of sending it to the printer in this form.

78 Wassily Kandinsky,
 *Study for
 Improvisation
 Gorge,* 1914

79 Wassily Kandinsky, *Improvisation Gorge*, 1914

I can only decide after I have been through it again thoroughly. In any case, your delay makes it doubtful whether it will be published in time for the Autumn Salon.

I should like once again to remind you please to obtain the necessary papers for the marriage while you are there [in Petersburg]. I have already told you on various occasions that I dislike it when *you* write "Mrs. Münter" in the address. I *only* like to be addressed that way when talking to people who want to show me their respect — "close acquaintances" who are courteous. If this had occurred to you yourself & long ago, I could feel differently & more comfortable about it coming from you too. At

any rate it is for you and you alone to give me a right to the title. I am nervous & restless here & will therefore travel home next week & await you there. I have told everyone here that I have to be there at the end of the month. I can't write any more today.

BONN,
AUGUST 25, 1913
GABRIELE MÜNTER TO
WASSILY KANDINSKY

My dear Wassja — I want to send one more quick letter to Moscow in order to make a bit of an improvement to the impression of the last letter. I was feeling homesick & had been looking forward to being with you again at last & traveling with you — & then you put off your return even longer & it all comes back to me — how in the last few years you have always been against me — inconsiderate, unkind & unjust — & I had to write to you about the photos — I felt very bad because I was thinking what the last few years have been like. I don't want to think about it....

I had been looking forward to Berlin with you. Anja wrote and told me she thinks it very unlikely that we shall go there now [to the opening of the Erster Deutscher Herbstsalon on September 18, 1913]. If we can't have a room together there and I have to travel as a Miss and worry about the police because of the registration, then in the end I'd rather do without — I don't want things to be like in Sindelsdorf again — I just want to be together with you. I've now had enough of traveling around alone.

MOSCOW,
AUGUST 28, 1913
WASSILY KANDINSKY
TO GABRIELE MÜNTER

D. E. Many thanks for letter & card from Bonn (with scolding). I'm definitely leaving on Monday (today Thursday) & hope to be in Mch on the morning train next Sunday or Monday. Will let you know from Berlin. I am tired & worn out. But really must see to some very important matters. Much love!

Your W

Kandinsky spent the Easter of 1914 in Obermais, near Merano, with his mother and other Russian relatives; they arrived on April 9 and stayed just over a week. Then he returned with his mother to Munich, where a dinner party had been arranged.

D. E., happy Easter and *lots* of good paintings!...Did a lot of walking today. The older girls may also go out tomorrow: both have been coughing. The little one is enchanting. It was very hot today. Cold at night. All the best

<div align="right">Your W</div>

Mother, sister send regards.

MERANO,
APRIL 11, 1914
WASSILY KANDINSKY
TO GABRIELE MÜNTER

My dear Wasja — I really wanted to go on strike — but I fear your revenge. I'm lazy about writing — especially because there is so much to report. Anyway I've been busy the whole time with all kinds of nothing — I haven't yet had a brush in my hand....

How are you? What's new? Fanny is already to bed. I'm going to Anja's for lunch tomorrow. On Monday I'll probably be able to take it easy — on Tuesday Fanny is going to clean here — & after that I'm hoping to gradually get sorted out again. So now I have been a good girl & made my report & will even take it to the post. Greetings to your family, if they're interested. To you best wishes & regards.

<div align="right">Your Ella</div>

MUNICH,
APRIL 11, 1914
GABRIELE MÜNTER TO
WASSILY KANDINSKY

It was very muggy & I was dressed too warm — so I put my jacket over my arm & went shopping. City is beflagged & decorated for the Austrian crown prince. At 6 I had an ice at Teichlein's & I did some sketching there & on the street. Hope to paint again tomorrow for the first time. Up to now it wasn't very nice with the cleaning & my studio still isn't finished. I also had to tidy up at least here & there & that's how time went by. Hardly read anything — but had 2 long sessions playing piano. I mean practising. Am now getting to grips with a lovely sonata....

On Sunday I was at Anja's from 1 to just before 9 — tea shortly after 6 — did without supper....So you are both expected for dinner on Monday. What do you want to have? Chops?...

Am glad you are walking a lot & very much hope it will do you a lot of good!

MUNICH,
APRIL 14, 1914
GABRIELE MÜNTER TO
WASSILY KANDINSKY

Today is wonderfully nice weather and I can't wait to get out.... The printers in Moscow are on strike. So the "Spiritual" is put off till the fall. It would be too late now anyway. Much love!

<div align="right">Yr. W</div>

Regards to Fanny

MERANO,
APRIL 16-17, 1914
WASSILY KANDINSKY
TO GABRIELE MÜNTER

The following letter is the last piece of correspondence between Wassily Kandinsky and Gabriele Münter before the outbreak of the First World War.

MERANO,
APRIL 18, 1914
WASSILY KANDINSKY
TO GABRIELE MÜNTER

Dear Ella, I have written to Anja and asked her to come to dinner with us on Monday. She will doubtless come to the station anyway. Mother finds the idea of chops very acceptable....

I have grown accustomed to Merano: wonderful air, meals excellent, we are all doing nothing and getting fat — you'll notice that with me. No cares — I'm putting them all off till Munich....

Best wishes and see you soon Yr. W

Best regards to Fanny. Tell her to get a good rest tomorrow!

EPILOGUE

The war, exile in Scandinavia and Russia, and the final separation in 1917 marked the decisive watershed in both lives. In the 1920s Münter, who after 1917 had spent three desolately lonely years in Sweden and Denmark, went through a period of severe crises and depressions, living a very secluded life in her Murnau house, and spending the winters in various lodging houses in Munich. Then, in 1925, she went to Cologne and eventually to Berlin, where she began to involve herself in the art world again. But it was only after the development of the relationship with Johannes Eichner, her second partner — from 1928 onward — that her emotional condition became more stable and she was able to work properly. With Eichner she moved back to Murnau in 1931, and lived there for the rest of her life.

The break with Gabriele Münter was equally fateful for Kandinsky. However much he may have been to blame for the ending of the relationship — which was tragically bound up with the end of a historical era — it was for him an almost total break with his past. He never saw Murnau again, he never saw Munich again, and — most important of all — he never again saw most of his major prewar pictures, which he had left behind. Apart from those whose studios were destroyed in the air raids of the Second World War, hardly another artist of our century has been so inexorably cut off from his private and artistic past. The implications of this for Kandinsky's late painting are not always fully appreciated. True, when he came to the Bauhaus in 1921 at the invitation of Walter Gropius, he reencountered his old comrade Paul Klee, and later had contacts with Jawlensky for a time; but, as a visitor to Weimar once reported to Gabriele Münter, the rest of his life between "his student years and now" was "as if extinguished."

Through their lawyers, Kandinsky and Münter conducted a protracted battle — which lasted until 1926 — over the pictures and personal belongings that Kandinsky had left behind. Münter was not concerned with the material aspect: for her, it was a question of moral obligation. In the end some pictures were returned to Kandinsky, but the great majority were put in storage with a Munich shipping company, the cost of which was borne by Münter for several

years. At the beginning of the 1930s, when the political situation was looking very uncertain, she removed this rich hoard of pictures by Kandinsky and other Blue Rider associates to her house in Murnau, where she faithfully preserved it through all the financial and material hardships of the Nazi years and the Second World War. To escape the persecutions of the Hitler regime, Kandinsky was forced to leave the Bauhaus in 1933; he moved to Neuilly-sur-Seine, near Paris, where he died in 1944. On the occasion of her eightieth birthday, in 1957, Gabriele Münter donated this priceless collection, together with many of her own works, to the Städtische Galerie im Lenbachhaus in Munich, thus enabling the public eye to feast anew on the fruits of the most important period of classic modern art in Germany.

Editor's note

The correspondence between Wassily Kandinsky and Gabriele Münter is stored in the archives of the Gabriele Münter- und Johannes Eichner-Stiftung, Munich. This also applies to all the other source material — diaries, memoirs, etc. — quoted in this book.

The editor has followed the policy of exactly reproducing the original texts, with all their idiosyncrasies of expression, spelling and punctuation. In the translation, this approach sometimes poses insuperable problems, which have made it necessary to make slight amendments in the interests of readability; as a rule, however, every effort has been made to preserve the appearance and specific tone of the original.

Many of the letters begin without any form of salutation. The closing words and signature have only been included where they follow on directly from the passages quoted. Paragraph divisions and indentation are as in the original; ellipses are indicated by dots.

Acknowledgments

This book could not have appeared in its present form without the assistance of Ilse Holzinger, the executive director of the Gabriele Münter- und Johannes Eichner-Stiftung, Munich, who not only transcribed the letters but also supplied photographs and other material, often at very short notice. I would like to take this opportunity of expressing my sincere thanks to her for her tireless cooperation, which was always granted in the friendliest and most generous spirit. My thanks are also due to Prof. Helmut Friedel, director of the Städtische Galerie im Lenbachhaus, Munich, and chairman of the Gabriele Münter- und Johannes Eichner-Stiftung, who allowed me a completely free hand in compiling this edition of the Kandinsky-Münter letters and gave the project his full support.

ANNEGRET HOBERG

Photograph Credits

Unless otherwise stated in the captions, all the works reproduced are oil paintings.

The transparencies for all works other than those listed below were kindly supplied by the Städtische Galerie im Lenbachhaus, Munich.

The black-and-white photographs were provided by the Gabriele Münter- und Johannes Eichner-Stiftung, Munich.

Gabriele-Münter-Haus, Murnau fig. 35
Karl Ernst Osthaus-Museum, Hagen fig. 51
Milwaukee Art Museum fig. 42
Museum Folkwang, Essen fig. 76
Private collection figs. 6, 23, 25, 44, 45, 49, 53, 55, 76
Schlossmuseum, Murnau fig. 48
Toyota Sogo Co. Ltd., Toyota-shi fig. 74